ARCTIC

With the generous support of

A. P. Møller og Hustru
Chastine Mc-Kinney Möllers Fond til almene Formaal

© Louisiana Museum of Modern Art and the contributors
Edited by Michael Juul Holm, Mathias Ussing Seeberg and Poul Erik Tøjner

Publishing Editor Nina Marie Poulsen
Graphic Design Mette Salomonsen / salomet grafik
Cover photo Darren Almond, *Arctic Plate 6*, 2003. Louisiana Museum of Modern Art
Photo Editors Sidse Buck and Kim Hansen
Translations from the Danish by Glen Garner (Tøjner, Rosing), James Manley (Expeditions, Trivia),
Mark Perrino (Seeberg, Kristensen) and Nichola Smalley (Ries)

Printed by Rosendahls, Esbjerg, Denmark 2013
ISBN: 978-87-92877-16-1

This catalogue is published on the occasion of the exhibition
ARCTIC 25 September 2013 – 2 February 2014
Curators Poul Erik Tøjner and Mathias Ussing Seeberg

Exhibition Architects Luise Hooge Lorenc and Mads Kjædegaard
Curatorial Assistant Dea Antonsen
Curatorial Coordinators Benedicte Brocks and Arne Schmidt-Petersen
Exhibition Design Marie D'Origny Lübecker and Jens Dan Johansen
Exhibition Producer / Conservator Jesper Lund Madsen

Photos: © Adam Lyberth (72); Ann Christine Eek / Etnografisk Museum, Universitetet i Oslo (92); © ARTHOTEK
(14, 19,22); Berglind Jona Hlynsdottir (4); Elke Walford / Hamburger Kunsthalle (18, 23); Fotografisk Atelier /
Det Kongelige Bibliotek (41, 42, 43, 44); Fyns Kunstmuseum (46, 47); Grenna Museum – Polarcenter / Svenska Sällskapet
för Antropologi och Geografi (82, 84, 85, 86, 90); Harry Ford / Nationalmuseet, Etnografisk Samling (104); Jacques Lathion /
Nasjonalmuseet for Kunst, Arkitektur og Design, Oslo (114, 119); Kim Hansen / Louisiana Museum of Modern Art (91);
Leo Hansen / Nationalmuseet, Etnografisk Samling (105); © Lord Snowdon / Condé Nast (54,57); © Mario Grisolli (70);
© McCord Museum (94, 95); Maine Womens Writers Collection, University of New England (61); Nasjonalbiblioteket,
Oslo (48,50,51,88); National Maritime Museum, Greenwich, London (36); Nationalmuseet, Etnografisk Samling (102);
© Nigel Green (68, 71); Ohio State University (66); © Polfoto / Corbis (100); © Polfoto / Mary Evans (67); Richard Beard /
Universty of Cambridge Scott Polar Research Institute (34,37); Sara Wheeler (98); © Scanpix (45, 53); © Scanpix /
ArcticPhoto (97, 122, 124); © Scanpix / Bridgeman (21, 24-25, 57, 64, 66); SciencePhotoLibrary (38, 45); © Smithsonian
American Art Museum (27); © Smithsonian Institution Libraries (126); Svend Funder (112); Søren Arke Petersen (31);
© Tate, London 2013 (16); Thomas Bjørneboe Berg /Naturama (63); Toni Ott (32); © Warner Bros. Entertainment Inc (60);
Wilson Bentley Digital Archives of the Jericho (28)

Louisiana Museum of Modern Art
www.louisiana.dk
Opening hours: Tues-Fri 11-22, Sat-Sun 11-18

Main Sponsor of Louisiana Museum of Modern Art

Sponsor of arcitectual exhibitions at Louisiana

EXPEDITIONS
POUL ERIK TØJNER

Foreword

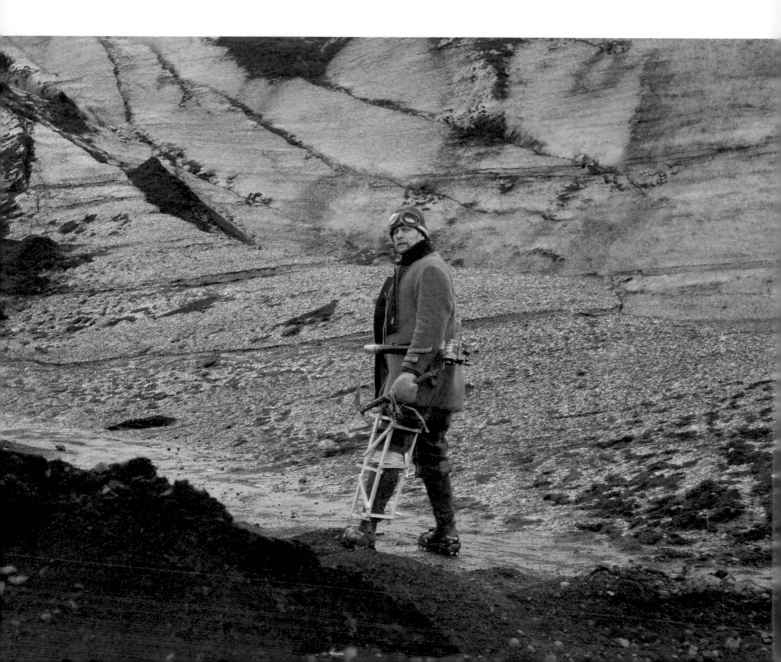

In the contemporary artist John Bock's video work *Skipholt*, we follow an explorer who struggles across a rugged landscape wearing a monstrous, poorly mounted backpack. The film recalls the finest images of noble, heroic men of great stamina, for it is based on one of our basic stories – man against nature – but it delivers these icons up to parody. The man with the backpack is his own worst enemy as he stumbles around aimlessly on his increasingly absurd expedition. It is completely enervating to watch, and finally the viewer just gives up because nothing happens, even though there are problems enough, so to speak, for our busy emissary. We find another wanderer in Darren Almond's video work *Arctic Pull*, in which parody has now been replaced by a monomaniac struggling through a blizzard in the dark, where everything is an indistinguishable mass around the protagonist who pulls a sledge across what can barely be called a landscape. The breathless exertions are conveyed to the viewers, who can feel pleased that they did not choose this ride from the palette of 'extreme sports'. Finally we find a third wayfarer in Guido van der Werve's video *Nummer Acht, Everything is going to be alright* (Number Eight, Everything . . .). Here we meet a man who is walking across the ice towards us, closely followed by an ultra-modern icebreaker that ploughs up a channel where the man has just passed.

Three men in a landscape, all images of Man in the Wilderness – and above all images with antecedents in a history that is itself full of images. Louisiana's major autumn exhibition – ARCTIC – presents this historical background as a foundational narrative of our culture and its use of images and ideas, myths and stagings. For that, more than anything else, is what the story of the conquest of the Arctic and the race to the North

Pole was: a major cultural project that called upon the greatest and most reckless heroes, including some who should have been wiser than they were. Heroes who were also nourished and supported by a culture that for 150 years, from the late 1700s on, hungered for a meeting with the unknown, and staged its own desire afterwards in the great images and stories and ideas that came to define the magical North – often before they had been there.

For many, the Arctic has always been a great, indefinable challenge for the human perspective on the planet we inhabit. It is as if our world in principle stops before we get there, for the vast Arctic landscape seems in no way designed for the purposes of an expansive civilisation. And it is also as if our world actually ends when we arrive there, because everything indicates that the melting of the northern ice sheet will have incalculable consequences for us. At present there is great interest in the Arctic – involving geopolitical conflicts among nations and climate action imperatives of a far-reaching kind – but the interest is not, as the cliché often has it, "greater than ever". For many, many years, the Arctic has been a fascinating and mysterious place, a place that preoccupied both the images of artists and the ideals of society – as in Arctic researcher Robert McGhee's striking description from the book *The Last Imaginary Place*:

"In records left by the scholars of early civilisations, the Arctic was one of those distant and fantastic lands. No traveller's tale of the North was too bizarre to be believed. It is startling to realise that remnants of this view still cling to the region. The Arctic is still a place that is seen primarily through the eyes of outsiders, a territory known to the world from explorer's narratives rather than from the writings, drawings and films of its own people. To most southerners the Arctic remains what is was to their counterparts centuries and perhaps even millennia ago: the ultimate otherworld."

The Arctic as the ultimate *other* world – other than ours, of course. Even in the modern era, which is what Louisiana's exhibition covers, from around 1800 to the present day, a period when everyday enchantment is

said to be on the wane, pushed back by the Enlightenment, science and a general trend towards mapping the world down to smallest detail, the Arctic lives in our consciousness as a large number of impressions collected in images and stories. These are the images and stories that ARCTIC shows and tells, from Romanticism to the present. The Arctic has both captured great performances by individual painters, from Caspar David Friedrich to the next generation of English and American painters, and assumed a role in society's collective consciousness of civilised morality and its limits, in heroic ideals and in scientific ambitions to describe the magical territory, from the outermost to the innermost details. The Arctic is at once a borderless land, the number one arena of natural struggle, and to a certain extent the vast repository of our own memory, since the ice has been found by investigation to contain a record of the planet's relatively recent history.

ARCTIC is science, stories of heroes and visual art – reflected in longings, ideals and observations. The exhibition speaks, in one of its many dimensions, of five of the heroes and their expeditions who came to embody highly diverse chapters of the great epic of conquest: the absurd history of Sir John Franklin, who disappeared without a trace; the stylish history of Fridtjof Nansen; Captain Andrée's tragic journey by air; the almost parodic race between Cook and Peary to the North Pole; and our own great sledge driver, the beloved son of the landscape and the people, Knud Rasmussen. They were men of flesh and blood, of course, with personal ambitions, but they also became images of the society by which they were shaped, from which they departed, and to which some of them returned.

The artistic images – the Arctic genre's transformation of landscape painting into history painting – developed from speculation to fascination. The images from the 1800s – the sublime landscapes of Church, Landseer, Briton Riviere and others – served the purpose of making delight mixed with terror available to citizens who remained at a safe distance from the trials of the ice. The images were thus evocative expressions of the premises of the period, and to emphasise this we have chosen to show these images in an illustrative form in the exhibition, that gives them so powerful an effect that their theme is lifted out of the original and historical setting: varnished paintings in large gilt frames. We want the audience to see the motifs as motifs – not as paintings from that period. Artistic speculation about the maximum effect on the audience was replaced in the twentieth century by a fascination with the Arctic as a place where the human gaze either must unite with scientific observation or must withdraw and let the world appear in its own form, as ice, sound, silence, cold. The German artist Sigmar Polke loved alchemy, and was a master of allowing the crystallisation processes in the material to take over the formation of imagery, while a colleague of his generation, Gerhard Richter, translated his own Polaroid photos into a strange, dream-like and totally unheroic painting. And since then, contemporary art has taken over – now with all the stereotypes of the past in play beside a renewed interest in the Arctic as a physical world where people actually adapt and live.

ARCTIC is an exhibition with the same approach to its material as Louisiana's major architectural exhibitions. In exhibitions of this kind, we sometimes take the liberty of letting artistic works behave as though they were cultural-historical objects (which they of course also are), while on the other hand an attempt is made to draw from the cultural-historical objects the images – the aesthetic dimension – that they also bear. We do this because we have always believed that art is not only art but also contains stories about the society we live in, and that art thereby lives on in the new stories we sometimes find to replace the old ones. If we are to talk about the Arctic today, as we must – and if the clichés about the great, pristine, vulnerable landscape are to flow freely from our pens – as they do – it is important to know the earlier history, the great past, the foundational tale of the ultimate other world.‡

Poul Erik Tøjner, Director and Curator
& **Mathias Ussing Seeberg**, Curator

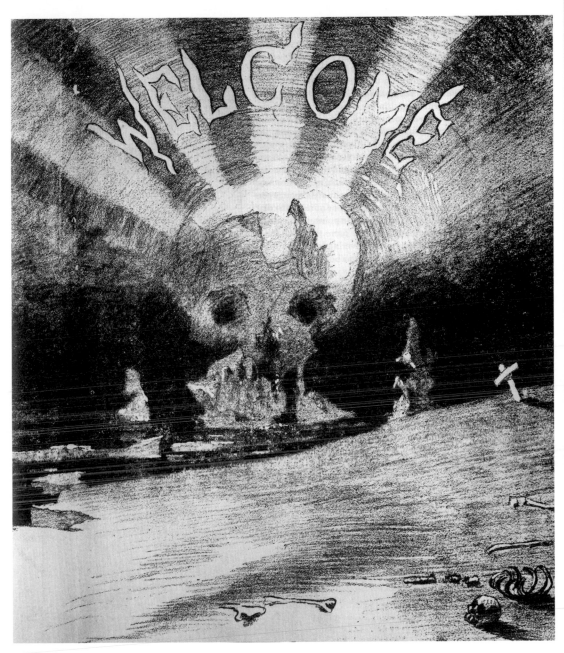

TRIVIA **A WARM WELCOME**

It was a warm welcome to the Arctic that an English magazine launched in the wake of the disappearance of Franklin and the many attempts to find him. However, the tragedy had to yield to a morbid sense of humour that makes the poster look like the entrance to the cabinet of horrors in an amusement park – rather than being about the noble strife of ambitious heroes with the cold north. In the years after Franklin & Co, the Arctic as 'event culture' became so fashionable that people in London began to talk about 'the Arctic season', just as there were seasons for hunting, sports and other things. This kind of success in the experience economy corresponds to a failure in the real word of ice and snow and storm and darkness – so when the Arctic appears on the poster with all the related signal effect, the meltdown is already on the way, and the heroes set off on new adventures in other places. And that is exactly what happened: from around 1900 and for a few years to come, the fascination with the great north abated and society's 'exceptional' types set new courses.

WELCOME
Artist unknown
Welcome, n. d.

Clarity in the North

Man and nature. Curiosity, thirst for knowledge and steely focus have driven people to the Arctic. But what they took away was not always the same as they came for. The place changes you, triggering realizations that may match your intentions but do not necessarily meet them. Geologist and Greenland expert Minik Rosing writes about expedition cultures and polar research, yesterday and today.

*T*t is almost impossible to say polar without also saying explorer. For three centuries, the planet's poles have exerted a magnetic attraction on people who yearn to explore the world.

In antiquity, the Arctic was defined as the part of the Earth from which the constellation Ursa Major, or the Great Bear (*Arctos* in Greek), could be seen. In the late 19th century, the geographer Martin Vahl endeavored to define climatic belts based on the zoning that is evident in the vegetation when traveling from south to north. According to Vahl, the Arctic, as he called the northern polar belt, is defined by the boundary between forest and tundra. A more quantitative definition defines the Arctic as having an average temperature below 10°C during the hottest month of summer. The astronomical definition of the polar circle, which some consider the border of the Arctic, is that midnight sun and polar night occur north of this line, which is located at 66.33° N.

Humans have inhabited the present-day Arctic for more than five thousand years. The first people in the Arctic followed the receding ice caps north at the end of the last Ice Age, around ten thousand years ago, colonizing the country as it was released from the ice. The Sami populated the European Arctic; Eskimo cultures entered eastern Siberia, Alaska, northern Canada and Greenland; while other Mongolian peoples established Arctic cultures in the rest of Siberia. Even Turks set up a branch in the Arctic. Known as the Yakut, they still live as reindeer breeders, like the Sami, but with a clear line back to their Turkish origin.

What propelled the colonization of the Arctic is not clear. To some extent, of course, the food resources emerging in the new, virgin land drew people in from all the surrounding cultures, but it is also conceivable that hunter-gatherers were increasingly being marginalized by the first great agricultural empires and forced ever farther into the remote corners of the world, including north to the Arctic.

Because biological productivity is not very great in the Arctic, the population is thinly spread out across vast areas. Most Arctic peoples are nomads because of the need to move around as the local larders around a camp are exhausted. The nomadic way of life produces a different relationship to the land than farming cultures' sense of property. Boundless spaces are still a central element in the worldview of many Arctic peoples and the thought that humans can own the land is difficult to relate to, even for a modern Arctic cosmopolitan.

THE NORSE SETTLERS IN GREENLAND

About 1,000 years ago, the first Norse farmers settled in the North and attempted to apply their accustomed way of life as farmers to Arctic conditions. The earliest Norse exploration of the North Atlantic was led by Norwegian Vikings seeking tax shelter in Iceland. Names of kings like Harald Fairhair and Eric Bloodaxe would suggest that the Norsemen were driven northwest over the Atlantic less by the dream of living in the Arctic than by the murderous tone of the tax debate in their home country. Further exploration westward from Iceland to Greenland and Vinland seems to have sprung from similar

motives. Eric the Red, who discovered Greenland, began his voyage after he was outlawed in Iceland for repeated acts of more or less premeditated murder. Hence, it seems to have been a strong incentive to leave Iceland, rather than actual wanderlust, that drove Eric deeper into the Arctic.

While Norse culture survives in Iceland today, the last Norse settlers disappeared from Greenland during the 15th century. They do not seem to have been missed much in their old home countries, Iceland and Norway. It was not until Frederik IV of Denmark and Norway dispatched the minister Hans Egede and his wife Gertrud Rask to Greenland in 1721 that the first serious attempt was made to restore the connection to the old land of the crown. Egede was sent out to reestablish a link to the Greenlandic subjects and possibly resurrect their Christian faith, which was presumed to have lapsed a bit after a three-century absence of high-church stimulation. Hans Egede did not find his old Scandinavian compatriots. Instead, he came across an Inuit population that did not descend from the Norse settlers and had never heard of Jesus, God or original sin. Either the settlers were to be found in as yet unexplored corners of Greenland or they had perished. Hans Egede, and later his sons, Poul and Niels, never abandoned hope of finding the lost Norse settlers, and through most of the 18th century they searched the accessible stretches of Greenland's coastline. The search for the Viking ancestors kicked off an actual systematic exploration of Greenland and, through the Greenlandic gateway, the rest of the western Arctic.

At roughly the same time that Egede started exploring Greenland,

Peter the Great dispatched Vitus Bering, a Russian naval officer of Danish extraction, northeast around Russia to find a sea passage to America and Japan. Bering mapped the entire north coast of Russia, noting that America and Russia were not connected but separated by a strait – now known as the Bering Strait – linking the Arctic Ocean to the Pacific. Bering continued his systematic exploration of the Russian polar coast and Alaska over the next 20 years until his death on the 2nd Kamchatka Expedition in 1741.

THE NORTHWEST PASSAGE

The first voyages north followed in the slipstream of the great European voyages of discovery that got under way back in the 15th century. The Portuguese explorer Vasco da Gama discovered a sea route to India south around Africa in 1498. At roughly the same time that the Norse settlers threw in the towel and perished or left Greenland, and European culture lost its only foothold on the North American continent, Columbus landed in West India in 1492. Soon, Portugal and Spain had monopolized the trade routes over the South Atlantic, and England had to find other routes if they wanted to assert themselves in the new global market. The British Parliament offered a prize to the person who could find a northern sea route to Asia. In 1497, John Cabot, sailing for the English crown, landed in North America as the first European since the great Vinland voyages of the early Viking age. A steady stream of English expeditions followed, looking for the seemingly mythic Northwest Passage. While Frobisher, Hudson, Davis and Franklin all left their

names on the map of northeastern America, they never found the route to Asia.

James Cook decided to try the back way and in 1778 he sailed through the Bering Strait to the Arctic Ocean but had to turn back on account of impassable ice. He returned southward to Hawaii, where he allegedly ended his incredible and successful expedition as a particularly exotic and precious item on the menu at a gathering of island chiefs.

It would take a Norwegian to finally sail and seal the Northwest Passage. In 1903-06, Roald Amundsen breached the passage in the good ship Gjøa, while conducting geophysical research and locating the magnetic North Pole. A few years prior, the Swedish mineralogist Adolf Nordenskjöld, on the Vega Expedition, had completed the first complete journey through the Northeast Passage to Asia, cementing what you might call the Nordic method as the most successful for Arctic exploration.

CULTURAL EXCHANGE IN THE NORTH

As we have seen, the Nordic expedition model was established in the time of Hans Egede. Over time, as trips up and down Greenland's west coast failed to locate any Norse settlements, Egede increased his missionary work among Greenland's Inuit population, whose ancestors had emigrated from Canada at the same time that things started going south for the Norse settlers.

During the colonization, the local Inuit enthusiastically took in all the colorful yarns from the Bible, along with the guns, gunpowder, bullets and split peas from the store, while they were a bit more reserved

about the Lutheran view of sexual relations, the virtue of work and the postponement of rewards to the hereafter.

Over the course of the 17th and 18th centuries, a fruitful cultural exchange emerged between the local Greenlanders and the arriving missionaries, traders and scientists. A young Danish cooper, Peder Olsen Walløe, who helped build the Danish colony, was instantly assimilated into the local Greenlandic population. He quickly learned to speak Greenlandic and adopted the Eskimo way of life. Over time, as the search for the Norse settlers led farther and farther away from the mother colony at Godthåb, the logistics became increasingly impossible. Introducing the use of local means of transportation, Walløe in 1751 traveled all the way to the southernmost part of Greenland, through Prince Christian's Sound and around to the east coast in a Greenlandic "woman's boat," or *umiak*. As a consequence, he founded a tradition that would last for the next two centuries.

A lifetime later, a Danish captain-lieutenant, W. A. Graah, made a journey up the east coast of Greenland. His expedition also failed to find the fabled descendants of the Norse settlers, putting to shame the original argument for Danish supremacy over Greenland. However, when Graah returned to Copenhagen in 1830 with important surveys of the east-coast landscape, flora and fauna, the mission and the ensuing trade in the meantime had blossomed to the point that Danish colonies had been established from Upernavik in the north to Frederiksdal in the south. The Danish presence in Greenland had a new rationale, and educating and enlightening the local population and revenues from trading, whaling and mining became new motives of colonization.

The Danish settlers quickly learned the Eskimo transportation technology, which as late as the mid-20th century was the only reliable one for traveling in the Arctic, and they learned to live and survive in the country. Forming the basis of the Scandinavian Arctic research tradition, this mutual cultural exchange was a major reason behind the success of Fridtjof Nansen, Roald Amundsen, Knud Rasmussen and Lauge Koch. All the successful expeditions were predicated on Arctic nature and profited from the experience of the local Greenlanders living in it. Ships were built to withstand the movements of the pack ice. Provisions were packed to accommodate for the colossal metabolism required to stay warm during the polar winter, and Eskimo and Sami technologies were integrated into dress and means of transportation. Modeled on Graah's boat trip, Scandinavians traveled with and like the locals, bringing along scientists from various disciplines to record and document the Arctic world.

OFFICERS AND GENTLEMEN
There are interesting differences between the Anglo-Saxon and the Scandinavian traditions of polar research. In English, the standard term is "polar explorer," while we say "polar researcher" in Scandinavia. The earliest English inspiration was the dream of finding a short, practical sea route to India. The goal of the English expeditions was to go through the Arctic and arrive at something else entirely, something familiar, on the other side. The Arctic itself and the region's natural phenomena and cultures were not the immediate goal. It did become a sport, though, over time, and the nature of the English project in the Arctic changed. The goal of the English gentleman-explorer was to travel and conquer remote, untouched lands, while proving the global validity of British culture. English and American expeditions were conducted with great pomp and circumstance. Gentlemen with impressive titles and matching uniforms brought small pockets of landed gentry life farther and farther north and south. Actual scientists rarely went along on the expeditions, and the goal seems largely to have been to prove that the proud traditions of the motherland could survive even under the most extreme conditions. Furnishings for entire apartments, including silver pots, candelabras, pianos and easy chairs, were transported across the ice by manpower. The central British motive seems to have been to prove that anything was possible without having to give up one's British cultural dignity and the corresponding array of domestic conveniences.

So, there is a fundamental difference between the Scandinavian and the Anglo-Saxon methods and goals of polar exploration and research. For the Nordic researchers, the Arctic was heartland, a natural extension of the domestic sphere of interest. They were highly interested in studying the Arctic region's natural phenomena, cultural history and resource basis for permanent settlements. To the Scandinavian traveler, exploration is a step in cataloguing the inventory of the home. For the Anglo-Saxon and, to a certain extent, the German explorer, the Arctic is an enemy to be conquered.

It is a scene for displaying audacity and death-defiance, in the same way as in the British colonies further south. The Arctic is a barrier to be surmounted to give civilization access to the goods that distinguish sophisticated, civilized society. Extending this, in Anglo-Saxon and, to some degree, German art, we find dramatic depictions of shipwrecks, bear attacks and inhuman exertions. In Scandinavian expedition art, we generally find national-romantic subjects with a folkloric tinge or sober illustrations of isolated natural phenomena, such as northern lights, glacial caves or geological structures. A painting from Gustav Holm's 1883-85 boat expedition to Ammassalik shows a delicate, thin-skinned umiak sailing through tightly packed ice without a hint of drama. The sun casts a mild light on the scene, the Danish flag flutters and the female rowers are lovely and cheerful. We are on the domestic front here and the world is a friendly place.

HUMANITY ON THE PLANET, IN THE WORLD

In the closing decades of the 20th century, humankind began to see itself and its role in the world in a new light. The recognition that the world is finite and fragile hit us all at once, it is said, when NASA published the first photo of the Earth seen from space. The picture, taken on December 7, 1972, by the crew of the Apollo 17 on their way to the Moon, is probably the most seen photo of all time. It shows a small, unfathomably beautiful but also frighteningly lonely and vulnerable planet in vast, empty, ice-cold space. The picture makes it obvious to everyone that our existence is utterly dependent on the planet's

resources and fragile ecological balance. The same technology that made it possible for us to see ourselves from space gave us powers comparable to the forces of nature.

Influenced by this recognition, the nature of our understanding of the Arctic has changed. The balance of power between the human polar traveler and immense, harsh Arctic nature has tipped. The Arctic nature we once fought to conquer we now must work to protect. We have introduced the term "fragile Arctic nature." The polar bear that, in paintings from past centuries, viciously set upon helpless, terrified polar explorers is now portrayed sitting on the last ice floe in the Polar Sea, with imploring eyes, waiting for help from today's polar researchers.

Today, a great deal of polar research involves deciphering the archives of past climates and atmospheric greenhouse-gas contents that are frozen into the ice caps of the Arctic and Greenland.

THE MAGNETIC POLE

The Scandinavian tradition of polar research that involved finding the most efficient way to travel in the region has emerged victorious, and we have learned to travel everywhere and in all seasons. The natural conditions of the Arctic no longer regulate access to it. The road through the Arctic world is no longer closed to everyone but a few brave and strong men. Anyone can go on a group tour to the North Pole, and a polar researcher with Coke-bottle glasses and a pacemaker has the same odds of succeeding as a grizzled ironman. Now that Arctic nature no longer limits traffic, humans have started regulating it themselves and the Arctic is now

one of the most comprehensively regulated regions on the planet. The nations that surround the Arctic Ocean are peacefully trying to decide on the distribution of the territory and the access to resources based on international law. A good deal of Arctic research now involves creating a scientific basis for the most lawful way to advance national claims. Is the Lomonosov Ridge a natural extension of the Greenlandic continent into the Polar Sea? Where does the continental slope meet the ocean floor north of Russia? Such questions have become the object of extensive research programs. With them, scientific interest in the Arctic has moved away from mapping the open, barren spaces and down below the surface of the ice.

The formal occasion for Arctic research has changed, access has changed and the scope of Arctic research has widened exponentially in recent centuries. The Arctic itself is changing. The sea ice is disappearing from the Arctic Ocean and the Arctic coasts, Greenland's ice sheet is melting and new land is appearing as the ice withdraws. The once so mythical passages between Asia, Europe and America are now open to shipping and are used by an increasing number of freighters.

But the Arctic has kept its allure. As scientists we have found new reasons for operating in the Arctic. While the relevance of Arctic research has never been greater than it is today, we are oddly bashful about our motivations for returning year after year to our Arctic fields of work. Even the most sober and unflappable scientist is impacted by the Arctic. There is a unique and unmatched atmosphere about the frigid landscape. The air is clear and

visibility is limited only by the curvature of the Earth. No treetops are shook by the wind, and the mountains lie calm and unconcerned, as they have for billions of years. The scenery inspires an incomprehensible calm. Not a calm deriving from comfort or the absence of danger, but a calm that comes creeping in as nature convinces you about your utter insignificance in the greater scheme of things. We keep going back because the Arctic is still *nature* and because there, as one of the last places on the planet, we can encounter nature without humans. Gazing out across the endless, deserted Arctic, we see a world we cannot contain or control. Encountering a nature without people, we are confronted with ourselves and, not infrequently, this encounter finds expression in profoundly relevant research and art that is not

about the Arctic phenomena we set out to describe but about being human in the world. ‡

Minik Rosing (b. 1957), Danish-Greenlandic professor of geology at the Danish Museum of Natural History and the Geological Museum in Copenhagen, has led several prominent research expeditions to Greenland, most recently the Galathea 3 Expedition in 2006, and has researched and written widely about Arctic geology.

CARL RASMUSSEN
Gustav Holm's Umiak Expedition to Ammassalik 1883-85, 1891
Naja Pedersen

The
Wide
World

Arctic Images. Our conception of the Arctic was an idea before it was a reality, and it tells as much about our own culture, as it does about the actual Northern regions. Poul Erik Tøjner, the director of Louisiana, writes about the polar exlorers, arctic fantasies and art.

"Stories, the true and the false, have gradually accumulated to form the vision of a distant and fantastic Arctic as seen through the window of Western culture ... This Arctic is not so much a region as a dream: the dream of a unique, unattainable and compellingly attractive world. It is the last imaginary place."

Robert McGhee,
The Last Imaginary Place

Witnesses to Captain Andrée's fatal balloon launch from Svalbard on July 11, 1897, reported that Andrée, just before departure, seemed to know that everything would go wrong. Though it remained unspoken, a darkened gaze and a melancholy mien foresaw the horrors ahead. Everything did go wrong. A few hundred meters after lift-off, the balloon loses its drag rope and from that point on the explorers lose both altitude and their bearings, make an emergency landing a few days later, wander aimlessly around the inescapable pack ice, pitch camp on a tiny island and die. Why did Andrée leave? What was he trapped by, in the intersection between masculine pride and alluring land? What were the images that had led him there? What kind of a place is the Arctic?

When we speak of places in the world, concepts or memories are in play. They are directed at the place, connecting with and framing it. Landscape, accordingly, is something that the human gaze or human action sets up in unbounded nature. Landscape is not just nature. It is this place, not somewhere else. It is there and not here, or here and not there. Something is a place because something has *taken* place – there. It can be my secret place, my favorite place. Las Vegas is a place I have never been. The toilet is the place where even the king goes alone. There are places of crime and places of trade. All of them involve us somehow connecting with a defined space. Only then does it become a place. Outer space, then, is not a place; while there is plenty of yearning directed at it, it is simply too big.

Is the Arctic a place? Is the Arctic a landscape? Considering the icy wastes, frequent absence of a sense of scale, polar mirages, sundogs, northern lights and the kind of weather that makes everything new again every time a storm blows over, considering the whole loss of orientation reported by expedition after expedition – those of them that did return – it seems appropriate to call the Arctic, not unlike outer space, a non-place. It is too big to be grasped as a project, too big for anyone to claim it for themselves, too unbounded – though boundaries have been set, scientifically – for anyone to connect with it. One can travel in it but not really travel to it. It is nature's answer to Los Angeles, the wide world, centerless – you are where you are. Yet there is one feature of the Arctic – at least in people's minds – that has made it the ultimate place, a heightened place, a place you can just reach, if at all, but not really be at. That is the North Pole, of course, the geographical fiction that has exerted such a tremendous draw on people and so, in spite of everything, makes the Arctic a *kind of* place[1] – even though no one from the late 18th century and far into the 19th century really distinguished between the Arctic and the North Pole, just as no one, incidentally, saw Antarctica as anything but a franchise of the Arctic, either. The latter did not change until Scott's death at the South Pole.

So, what kind of place is the Arctic? The first answer is that the

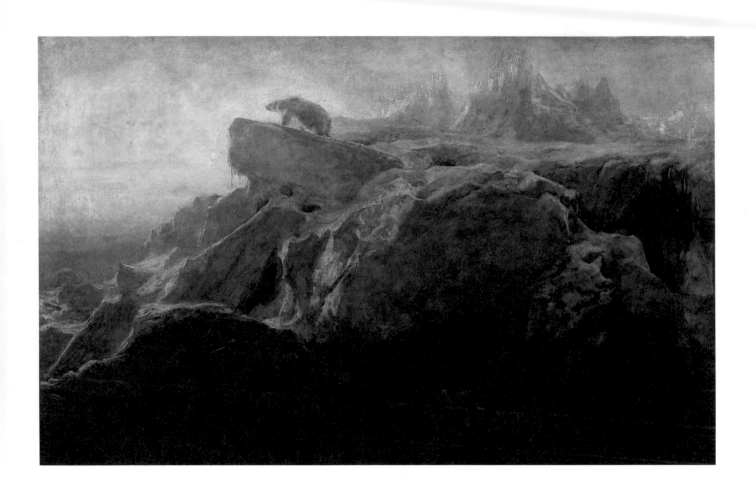

Arctic, as a place or a landscape, was an idea before it was a reality. That is not unique to the Arctic but applies to the entire landscape category. "Landscapes are culture before they are nature," as Simon Schama says in his great, groundbreaking book *Landscape & Memory*.[2] Historically, the idea of North – an idea that thrives in many places around the globe and is not limited to the Northern Hemisphere[3] – ranges from the simple, cartographical definition of the North Pole, that is, the actual place where all the longitudes come together and from which a person can only go, well, south. In between cartographical objectivity – which, it should be noted, did not emerge until the early 20th century – and the psychological sense of North, lie the more fanciful and bizarre notions that characterized the public discourse and the explorers up until the late 19th century: the Arctic Ocean as an open sea, the North Pole as a new continent with an unknown civilization,[4] the centre of the ice cap as a fertile oasis (an idea promoted by Nordenskiöld, the illustrious Finnish-Swedish hero, the discoverer of the Northeast Passage,[5] Nansen's mentor) or, finally, the pole as a gigantic hole in the sea, a maelstrom leading to the core of the earth. The idea of the Arctic as a magical place is also found among the Arctic inhabitants. The Russian Sami thought of the Arctic islands of the White Sea as an interstice, a space between their world and the great beyond, for which reason they buried their shamans there.

Later, people had to see if the reality matched the notions, and the voyages to the North Pole took their beginning. Rehearsals for this genre of reckless adventure, you might say, had been going on for centuries. Before it was the Pole, the point, it was the passage – a way around America to China. In the 18th century, making it *through* the Arctic and out on the other side was the great geopolitical dress rehearsal for yet another world conquest of a lucrative nature and so was driven by merchants – treasures from the North, furs and narwhal tusks, had been among the most precious artifacts of European courts since the Renaissance. Later came the 19th century's more symbolic, and thus in actuality relatively meaningless, push for the point. Now it was no longer about getting through but getting *there* – and, not least, *back* again, though to the most daring among them the former seemed more important than the latter. Its existence, very early on, even in the quest for the Northwest Passage, turned out to be beyond commercial interests, owing to complicated weather conditions, and almost from the very beginning the whole endeavor was layered in a far greater and symbolic narrative. The men of the Royal Navy were largely propelled by rewards and social status in the salons of Victorian England.[6] Even as late as the present day, travelling to the North was not just a voyage north but often a project with a baggage of distinct ethical and esthetical ideas: "One of the persistent myths of the North in our time is that the exploration of the Arctic is morally pure, connected with concepts such as askesis and self-knowledge."[7] The Arctic, in other words, is an ideographical place before it is a geographical place.

II. LANDSCAPE AS CONCEPT

Approaching, by way of introduction, the Arctic in the above, slightly abstract way – that is, discussing the

text and the author, the exhibition and the curator, not the explorers in the real world of sea ice – it is easy to disappear down the rabbit hole of over-interpretation and self-confirmation, where everything becomes something else and more than what it was and where specific stories become adventures loaded with symbolism and hidden motives. That will not do, of course. The Arctic *is* ice and snow and water and rocks, animal and human life, light and darkness, frost, thaw, silence and frenzied storms. Even so, one ought to risk an eye in the service of identification, so that we do not end up in the unimaginative world of under-interpretation. The Arctic *was* a magical place, exerting a magnetic draw on people and nations.

That something is an ideographical place means that it is largely defined by all the legends circulating about it. "'Landscape' ... comprises the mythology, history, artistic conventions and all the other cultural factors and associations that allow us to define a homeland, a wilderness, a terrain of scenic marvels worthy of sightseeing, or a land so dangerous that it inspires dread and avoidance. I believe that the concept of 'Arctic' that is held in the minds and imaginations of those of us who live in more temperate parts of the world owes far more to these associations than it does to the actual physical reality of the North."[8] A wealth of well-documented and varied incentives underlies the many expeditions[9] north. Even so, the sum of the more prosaic interests in whale oil and shortcuts to the New World cannot fully account for the obsession, audacity and foolhardiness that characterize so many of these endeavors.

In other words, other factors are needed than commerce and trade, honor and glory, national ambitions and hardened and clichéd masculine ideals. They are at hand. They exist as ideas of an almost obsessive nature, as heroic dreams, the tantalizing joy at great dread, the fascination with the unknown – out there or deep within. As Cook, the self-proclaimed first man on the North Pole, wrote, "The greatest mystery, the greatest unknown, is not that beyond the frontiers of knowledge but that unknown capacity in the spirit within the inner man of self... Therein is the greatest field for exploration."[10]

The Arctic is what scholars of literature, using a Greek word, call *topos*[11] – a place or figure or motif that keeps appearing in our art and culture. That is exactly what the Arctic *was*, reaching a peak of intensity, curiously, in the years before anyone had made it through, or made it there, yet. Cultural production with the Arctic as topos was inversely proportional to the triumphs in the Polar seas. Once people had made it through, and made it there and back again, the cultural gaze turned elsewhere. Conquered land was never the preferred place of artists.

The production of Arctic constructs takes place in a vital interaction between steadily growing experiences and discoveries *and* an even more prolific image-creation and literature. The concepts that prevailed about the Arctic before anyone had made it through, and to the goal, not only drive the great voyage north, they are, of course, also born of experiences gained in the North. Imagination and representation blend together in the great myth of the Arctic. Every time someone had been "up there," someone else had to go. The

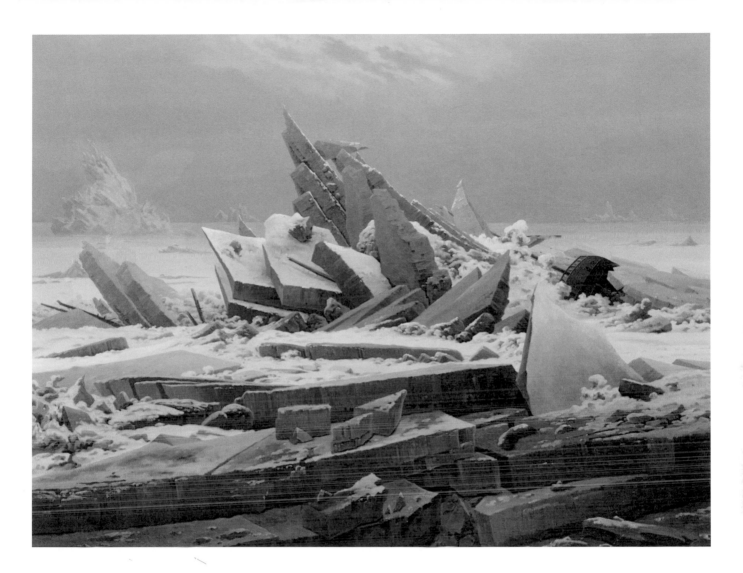

pomp and circumstance, the music, salutes, words of farewell, mission statements, the soaring oratory at various national geographic societies and admiralties, the promises made to the sponsors of the many expeditions, the declared goals and the half-concealed aspirations, the competitive announcements – the whole big preliminary fantasy runs into the damp, little notebooks of greasy, resigned entries made in the great winter night during month after month of waiting to break camp and push further north, or homewards to relive the voyage in memory. Memory, like expectation, is so rich in imagery and, while one might then think the frail notebook parchment was the delicate interface of truth between them, the story of the Arctic – and in turn, in this context, the truth about the Arctic as a place in the world and a place in the conceptual world – is precisely the combination of all of it. Let us quote Simon Schama again: "Landscapes are culture before they are nature; constructs of the imagination projected onto wood and water and rock. But it should also be acknowledged that once a certain idea of landscape, a myth, a vision, establishes itself in an actual place, it has a peculiar way of muddling categories, of making metaphors more real than their reference; of becoming, in fact, part of the scenery."[12]

CASPAR DAVID FRIEDRICH
Das Eismeer (Die gescheiterte Hoffnung),
1823-24. Polar Sea (The Wreck of Hope)
Oil on canvas, 97 x 127 cm
Hamburger Kunsthalle

The Arctic has been called "the last imaginary place," indicative of projections hurtling at their goal like projectiles, since the goal is so open and receptive and only responds once one is caught in the trap. We can imagine anything we want about the white world and the strange polar point, absolute north. One expedition after another consistently shows how wrong people were. The corrections were hard earned, even as they continued to stimulate additional new attempts.

The Arctic, in other words, is an image machine, however paradoxical that might be considering that few areas in the world are more devoid of imagery than the icy North; lacking any kind of organization, it can barely be called a landscape. Then again, it is likely this very quality that challenges the fabulations of fantasts as well as more levelheaded artistic forces, then as now, challenging them to capture, in concepts and words and images, that which is essentially distinguished by being elusive. That is, essentially, what we are celebrating with the Arctic: the boundaries of our existence, in every sense of the word. The Inuit could never understand what the white man wanted way out there in the white landscape. There was no food there, just evil spirits. It was beyond human determination.[13]

III. THE IDEA OF THE SUBLIME

A kind of landscape, then, the Arctic. But what are the images of it? The late 18th-century philosophical and aesthetic category of the sublime most clearly captures the epoch's terror-infused delight at the immense Arctic landscape, which, it should be added, many of the painters had never actually seen.

While beauty in the direct sense expresses a harmony in the world, allowing humans to feel at home, that the world is created in such a way that it accommodates human needs, the experience of the sublime initially points in the opposite direction. Sublime subject matter in art is subject matter that makes us feel small and vulnerable, on the wrong planet, even. That is, subject matter that scares us, that lets us know that we actually do not stand a chance when nature – it is generally that – unleashes its forces. And yet. Even though we *would not stand a chance if*, here we are, remote from danger, even thrilling to its representation in artful images, and maybe that is precisely the function of the sublime, as the philosopher Kant proposed in his *Kritik der Urteilskraft (1790)*, that it is an experience that enables man to be reborn as an even more masterful being. He can turn even disaster into an image. Or, put another way, the world of perception is not the only world of man, since he seems able to raise himself above this world in thought and reflection, showing himself to be a being with a moral sense.

The expeditions to the Arctic, particularly the English ones of the first half of the 19th century, can be mirrored in the edifying function of the sublime images they inspired. Expedition culture itself, not just the images of it, was a great moral project that served as a kind of test of cultural competence. Comparing the illustrations that accompany 18th-century and even earlier travel accounts with 19th-century ones, landscape in the early illustrations is completely downplayed and not unfolded in its sublime gestalt. Only in the 19th century does the biotope overwhelm man and spread out the

polar project in humanity's presentation of evidence regarding the moral resistance of societies.

In the Victorian Age, the Arctic expeditions become a grand edification project, in which success is not even crucial. Even failure, noble failure, is a potential sign of ethical superiority. The Arctic was custom made for this purpose: the heroes died a slow death, emaciated, isolated, fighting to the last man, while upholding the cardinal virtues, it was believed. The British historian Francis Spufford reaches the surprising conclusion that what these Victorian men learned in the far North, so far from civilization, in contrast to the idea of their machismo, was actually the essential *feminine* virtues of contemporary England: perseverance and resignation. Feminine adaptability (to marriage and society) is what it takes for these men – collectively, it should be added – to reconcile themselves to their fate. This is a difference of category from war, where the enemy *can* be vanquished. In the Arctic, the battle is lost before it has even begun.

Because of – or perhaps in spite of – that, in Britain circa 1850 the entire polar project was often represented as one big affirmation of the British character. Charles Dickens, who generally had a good sense of the underbelly of society, published the following salute in *Household Word*, a journal he established for that purpose: "For three hundred years the Arctic seas have now been visited by European sailors; their narratives supply some of the finest modern instances of human energy and daring, bent on a noble undertaking, and associated constantly with kindness, generosity, and simple piety. The history of Arctic

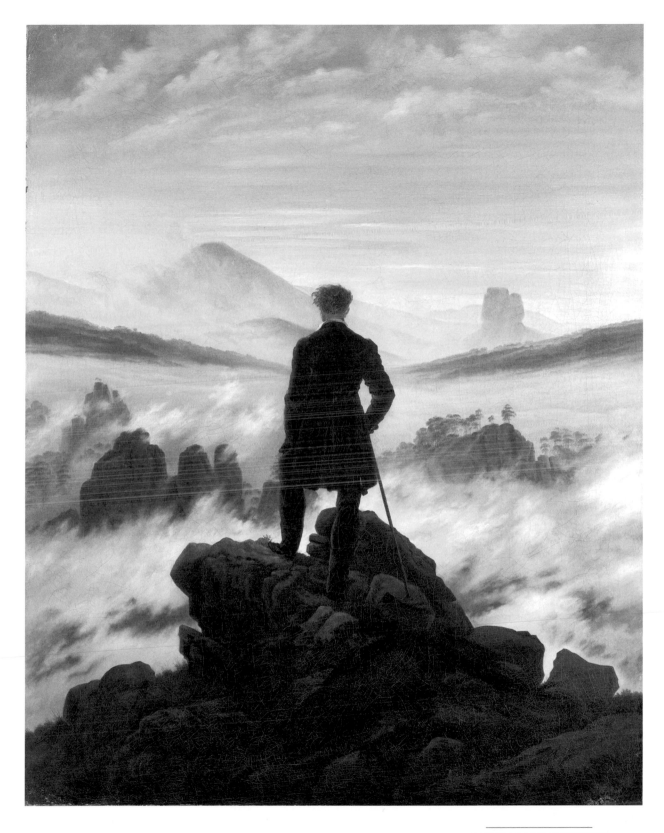

CASPAR DAVID FRIEDRICH
Der Wanderer über dem Nebelmeer, 1818
The Wanderer above the Sea of Fog
Oil on canvas, 98 x 74 cm
Hamburger Kunsthalle

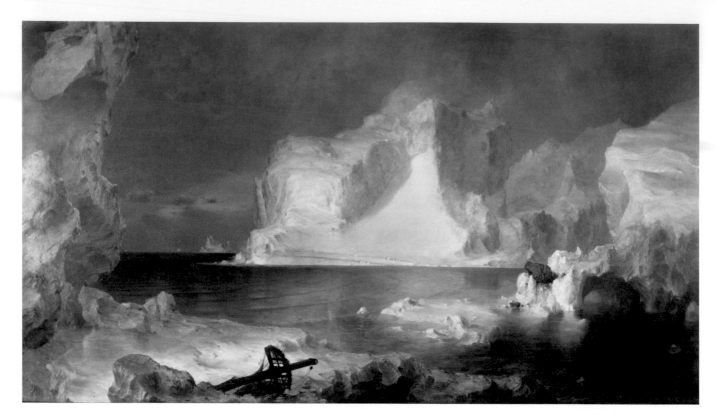

enterprise is stainless as the Arctic snows, clean to the core as an ice mountain."[14] In fact, nothing could be further from the truth, considering how disaster followed disaster in the great, dark epos of Arctic whiteness.

IV. THE SUBLIME AND ITS IMAGES

Before societal smugness swelled to that point, a number of artists, more cautiously and with greater aesthetic finesse and delicacy, had embedded nature's challenges of humanity in images of such intellectually elastic character that even the nature of art was commented upon – that is, appearing *in* its function, *with* its function. Looking at these images provided both an experience *and* an experience of the nature of that experience, a characteristic that walked hand in hand with the entry of art into museums, where any experience is co-determined by the institutional framework; after all, we know when we are in the space of fiction – the museum – and when we are not.

The German painter Caspar David Friedrich (1774-1840) was a master of problematizing sublime subject matter. Two of his paintings stand out in this context. One, *Das Eismeer* (The Sea of Ice) from 1823-24, shows the content of the sublime as subject matter. The other, *Der Wanderer über dem Nebelmeer* (Wanderer above the Sea of Fog), from around 1818, shows the bourgeois individual managing the sublime experience by transforming it into an image. In *Der Wanderer*, the viewer gets an ambassador *in* the image – the young man carefully leaning forward as he gazes across a vast mountain landscape. In other words, we are looking at someone who is looking. We are not ourselves gripped by the firsthand experience of the uncanny; we are, so to speak, at second hand. Someone is having a greater experience than we are: the

man in the picture. He is hardly able to transform what he is looking at – a vast landscape – into an image, and perhaps that is what is making him dizzy. But we do not get dizzy, because what we are seeing has already been transformed into an image – it *is* an image. Friedrich has painted the very mechanism that enables us to control the uncontrollable. His painting is a depiction of what art is and what art can do. Once you assimilate that idea, it almost seems to rebound back into the picture – perhaps the man in the picture looking at a landscape is actually a museumgoer. Friedrich was skeptical about the strategic, bourgeois edifying effect of the sublime. Given his Lutheran Christianity, he hardly believed that sublime subject matter could (or should) ultimately affirm human dominion. Indeed, *Der Wanderer* is also about the fact that no one can completely survey the world. Specifically, we cannot see what the person in the picture is seeing. His obstruction of our view is a hint of the fact that any gaze on the world is one among several angles on it.[15]

In the other Friedrich masterpiece, *Eismeer*, our ambassador inside the picture has plainly stuck his neck out too far: the whole embassy has capsized. It lies ruined in a nature that itself looks like the ruins of something that once held prouder status – the ship is stuck in the ghastly embrace of the ice; nothing escapes the mighty forces at work here. Shuddering, the museum audience is looking at the destruction of civilization, but again they can comfort themselves with the fact that we are remote from the event – even if the painted ice shards look like a floor we could almost step onto. We are look-

ing at a vision, a nightmare. The utopian longings of the expedition have turned into the dystopia of despair; there is nothing more to be had here. As Joseph René Bellot, a member of the party searching for the legendary missing John Franklin, wrote in his diary before he one day vanished instantly into an opening in the ice, never to be found again: "Moral nature seems to have abdicated, and nothing remains but a chaos without a purpose."[16]

Friedrich was a master of nature studies, who painted with his eyes wide open. A thoughtful painter, he believed fundamentally that paintings of nature subjects should look like they were made by human hand and not like a series of illusions. Having never been to the Arctic, he had to paint studies of ice floes in the Elbe river in winter and later export them into his polar scenario like theatrical set pieces. Note that this is exactly what it looks like – Friedrich appears to have repeated the same iceberg further back in *Eismeer*; he has *constructed* a painterly space.

Images of the sublime, then, were considered at least as edifying as images of beauty, which gives these images their singular duality of awe-inspiring grandeur and the relief of remoteness. We are present in the landscape, and yet we are not. In another case, the American painter Frederic Edwin Church (1826-1900) initially painted his monumental *The Icebergs* from 1861 without human traces in the picture, allowing the landscape to become a supernatural cathedral of beauty, God's own proposal for a world without us. It was only when the picture was exhibited in London, as part of the general "memorial service" in those years for England's lost son, Frank-

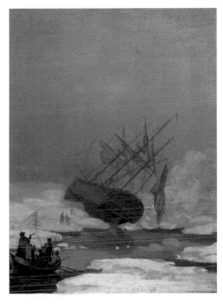

JOHN SARTIN AFTER A DRAWING BY ELISHA KENT KANE
Garves of Sir John Franklin's Men, 1854
Engraving
Collection of Russel A. Potter

CASPAR DAVID FRIEDRICH
Schiff im Eismeer, 1798
Ship in the Polar Sea
Oil on canvas, 30 x 22 cm
Hamburger Kunsthalle

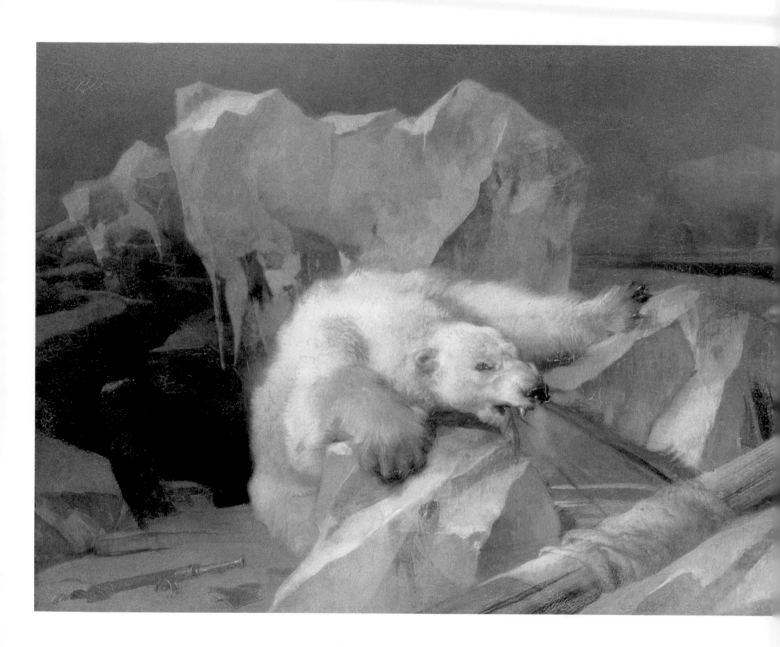

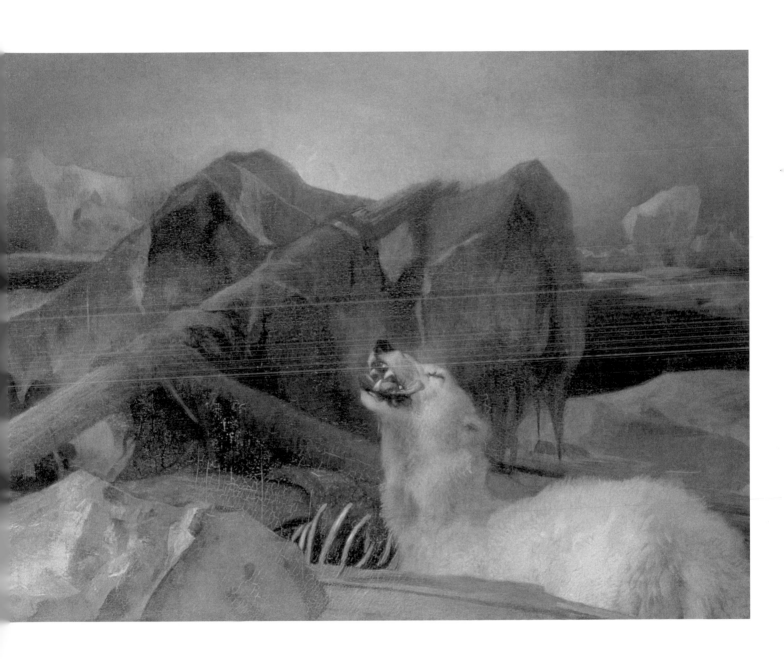

SIR EDWIN LANDSEER
Man Proposes, God Disposes, 1864
Oil on canvas, 91 x 245 cm
Royal Holloway, University of London

25

lin, that Church added wreckage to his panorama. Accordingly, the picture is both an homage to the crystalline beauty of Arctic nature and a warning about its belligerence. Two of the great author personalities of the time, Samuel Taylor Coleridge and Mary Shelley, had likewise described this dual Arctic. In her novel *Frankenstein*, written in 1818 – incidentally, the same year John Franklin set sail with two ships, the HMS Erebus and the HMS Terror – Shelley first represents the Arctic as a potential elevation of the human soul, an elastic expansion, before ultimately resigning at the inhuman, frozen, autonomous, emotionless, abstract world that the Arctic now remains. The novel in every way anticipates Victorian England's dual fascination with the frigid North.[17]

Friedrich's masterful and highly intelligent sense of the human quarrel with the grand landscape, with nature, had a long line of heirs, as the exploitation of gimmickry and shock effects was gradually perfected to the point that subject matter and technique won out over more subtle artistic reflection. What was common to many of these painters, however, was that they *had* been on polar expeditions – with the exception of Sir Edwin Landseer, who had to settle for studying the polar bears in Regent Park's London Zoo. Their compelling painterly clichés were formed around the experienced, not the imagined, world. Meanwhile, the Romantic intuition in Friedrich – his recurring interest in anything that shrouds the visible world in the parallel world of fantasy: fog, floods of light, shadows, twilight – was replaced by no-nonsense industriousness applied to making spectacular pictures. A trail to Hollywood had been blazed.

As the sublime images evolve, they lose their religious character, becoming more horrible but also more melodramatic. Nature strikes without spiritual footnotes. We are in the era of Darwinism,[18] God has withdrawn his hand and animals, including humans, are at each other's mercy in the most natural – that is, the most gruesome – way. Landseer's painting of polar bears is pure, unadulterated horror, holding no promise of happiness in any great beyond. Indeed, it has been interpreted as an image of the cannibalism rumored to have occurred on Franklin's lost expedition. The reference to cannibalism, once again, operates with the duality of the sublime: it seems ghastly but enhances the Arctic gimmickry, now without edification – it is an outright horror film! "Cannibalism, it might seem, would be the hardest thing to 'incorporate' into sublimity – and yet, when deftly displaced, it was precisely the horror at this 'last resource' that elevated the Arctic sublime to a new level of intensity."[19]

In the Arctic history of ideas, the entertainment industry thus takes over "the Arctic sublime," exhibiting dioramas that in animating ways illustrate the appearance of the grand landscape free of religious overtones. Yet, even here – the images are after all fiction – it still seems reasonable to claim that the public is both able to uphold its moral dominion as beings in nature, while at a remove from it, and exercise its sensibilities in the direction of titillation. At any rate, that becomes the formula for the entertainment industry's exploitation of disaster, sex and violence going forward.

The social function of such images is clear. First, they involve a kind of expropriation in the service of any empire. In Victorian England, in particular, they became pure "performances" in public space: "The empire on which the sun never set deployed these new technologies to reaffirm its dominion over geographical space: seeing was not only believing, but in an important sense *possession* as well."[20] Second, they tell of the great challenges humans encounter when we move beyond the reservation. Moreover, these images depict wildness with such seductive beauty that the despisers of everyday life simply had to go. Need and compulsion ran together and gained heroic momentum; the journey had already begun.

By the mid-19th century, "the arctic sublime" made headlines as a fashionable trend in London. The Arctic ice cap existed as a distant white film screen, on which British, and later American and Nordic, culture could project its more or less flamboyant images: "Fantastical worlds can become real in two ways – in the systems of the tyrant or the visions of the liberator. Likewise, real spaces can become fantastical in a twofold fashion. On the one hand, a tyrant might fictionalize a physical space so that he can exploit it. For instance, a developer desiring to transform a forest into profit might metaphorize the wooded ecosystem into raw material fit for human consumption. On the other hand, a liberator might transform a humanized region into the sublime laws sustaining the cosmos. A poet might release chthonic energies underlying city grids. Unmapped spaces are most likely to inspire such fantasies. The virginal ices covering the poles have for centuries stimulated robust visions, serving as blank screens on which men have projected deep reveries – tyrannical narcissisms and spiritual sublimities."[21] The artist's

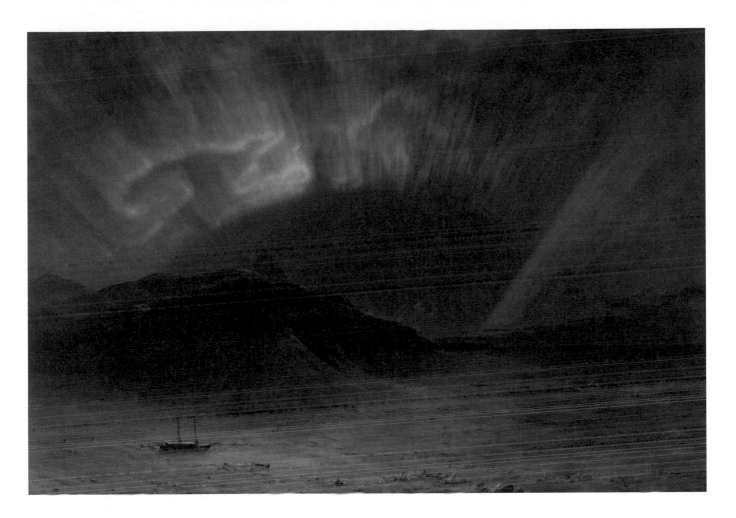

role to which the Arctic broadly appeals is that of the evocative and dramatizing artist, the artist who evokes grand emotions by showing grand things. The scale of the works grows in these years and, as landscapes, they are capable of competing with the history painting of the past. Everywhere it is about evoking a mood – awe and fascination – in the viewer. The sublime imagery encompasses almost anything of grand and mighty power and dynamism – from erupting volcanoes and piled-up crags to oceanic horrors, waterfalls and angry seas. Anywhere humans could appear in their insignificance against mighty nature, artists opened their paint boxes and transformed the unfathomable, the way too big, that which eludes us, into image.

V. ICE AS RECOGNITION

Ice and snow occupy a special position in the register of the sublime. The perception of ice over centuries of the European history of ideas is unequivocally negative. Ice is death's representative in the landscape. Frozen and hard, it rejects, and is entirely without, life. Employing the life-affirming optimism of the birth metaphor, we may say that glaciers calve, but we know they are simply expelling fragments indifferently drifting before crashing into their personal Titanic. Ice is the sublime subject, bar none, because it is so repulsive. Utterly impenetrable and inorganic, it is simply nature's answer to rigor mortis.

In the Romantic Age, however, when poets could also be scientists, and nature studies and poetry

FREDERIC EDWIN CHURCH
Aurora Borealis, 1865
Oil on canvas, 143 x 212 cm
Smithsonian American Art Museum
Gift of Eleanor Blodgett

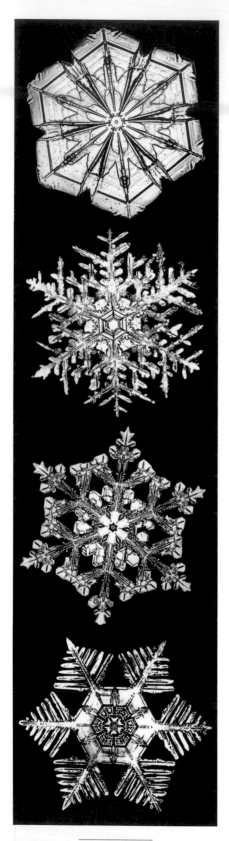

could be two sides of the same coin, the picture changes. The collective narcissistic passion, in which images serve as a mirror of ourselves, now confronts science, which approaches its subjects in altogether different ways. Art history, then, is not limited to passionate sublime images, since a kind of permanent backstory to the big image exists, consisting of all the *real* observations that are made, whether by sailors, returning home and telling artists of this and that, or by artists venturing out themselves. The artist as observer becomes a historical alternative to Romanticism's bloated *Sturm und Drang*, while the Arctic also holds an appeal to art that, rather than adding to the gimmicky dramaturgy in which the large canvases wallow, institutes and maintains a kinship between science and art: empirical passion – being there yourself, personally observing differences, capturing the changing light and landscape.

This is done not in the service of a predetermined higher cause but as a concrete expression of an encounter with a new world. Ice here becomes a key unlocking the innermost laws of life, not least owing to the insight it provides into the regularity of crystals, their shapes so fine that they evoke the notion of a creative force. Crystallography renders an image of ice as a prism through which nature's secrets, including electromagnetism, can be sussed out. Science thus answers the duality that already characterized the fascination with the sublime: We encounter both the abyss and edification in the experience of liminal situations. What kills us one day, arouses our minds to new enthusiasm the next. Ice is dead, but it is also a purification. Ice is pure infinity translated into landscape.

Ice is chaos – there seems to be no end to its expanse – and yet ice also contains the finest orders of geometric beauty, revealing laws of growth on a very fundamental level. In America, Wilson A. Bentley's (1865-1931) photographs of snowflakes – the first in the world – reveal this beauty to us. Later, the German artist Sigmar Polke (1941-2010) employs the morphological power of crystallization in *Hyperboräisch*, a monumental painting taking its title from the Greek word for the people of the North, while his peer and fellow countryman Gerhard Richter translates his own Polaroids into weirdly dreamlike, utterly unheroic painting.

What we are witnessing, from Romanticism on, is the transformation of ice from sublime threat into beauty in its full range of meanings – ice as clarity, ice as regularity, ice as withheld vitality that can be unleashed, ice as an image of structure. What was once threatening to humans – the Arctic chaos – has suddenly become attractive, the attraction involving both the great emancipation of humanity promised by the inhuman, beautiful landscape and the scientific opportunities and perspectives opened up by the study of ice. [22] The sciences that take ice as their object – glaciologically, geologically – have the aspect of a kind of fundamental archaeology, disciplines not only revealing the most ancient forces of the planet but also documenting its events, for example by analyzing the strata of ice core drilling samples. However, what is so crucial about this expanded potential of ice – from landscape to testimony of the innermost laws of life and the planet's short-term memory – is that there is no longer a need to travel north to understand this.

The expansion is also a contraction – ice is ice, whether it freezes in the stream outside the little house on the prairie or it lies hove-to as floes in the Polar seas. The American philosopher poet Thoreau, a master of packing the greatest perspectives into the smallest experiences of it, in a famous passage near the end of *Walden*, distancing himself from the many expeditions to far-off places, writes, "Be rather the Mungo Park, the Lewis and Clarke and Frobisher, of your own streams and oceans; explore your own higher latitudes."[23]

VI. THE SNOWBLIND

All along, the Polar voyages continue up to the 20th century. While in the first half of the 19th century, the Arctic was an obstacle to be overcome, and thus a stage for investigating the civilizational sustainability of cultures – which turned out so fatal for the British – it had, at the end of the century, become an arena for individualistic competition. Victorianism's essentially collective feats – captain and crew, kit and caboodle – give way to the personal ambition of individuals. Nationalistic rhetoric, science and sport run together in the ambition to reach the North Pole and can barely be told apart, a phenomenon we are familiar with from the American and Soviet race for the moon in the 20th century. Individual expeditions still drape themselves in national colors, but the difficulties, hardships and perils of the enterprise clearly imply individual obsession as a significant driving force. Pierre Berton sums it up in his magnum opus, *The Arctic Grail*, which chronicles the whole shebang, from 1818 to 1909: "There is much that is admirable in nineteenth-century polar exploration and much that is misguided, but there is also a great deal that is obsessive."[24]

SIGMAR POLKE
Hyperboräisch, 1994
Hyperborean. Synthetic resin on synthetic canvas, 300 x 502 cm
Louisiana Museum of Modern Art
Acquired with the support of
The New Carlsberg Foundation

The individualistic narrative replaces the collective images that, other things being equal, once united a culture. Action conquers dream and dread. Sublimity is performance. The Arctic project, thus, in a sense loses altitude during the course of the 19th century[25] until, finally, we are left with a nearly blind and desperate field in which performance serves no other purpose than performance itself. Reading accounts, say, of the conflict between a Cook and a Peary, ultimately, and despite the fact that we cannot help but be impressed by the courage of these people, the genre terms that come to mind are parody and grotesquery. Case in point, Peary writing to his mother from Washington, having returned from one of his first expeditions, with the really tough ones still ahead, "Remember, mother, I *must* have fame."[26] However, the world no longer had a need for what these heroes provided. They could barely sell their books about their exploits, when they finally did return, because modernity had overtaken a suddenly aged paradigm – notwithstanding that performances of this kind have been resurrected in our era as rampant extreme sports and the manic body worship practiced by entire populations in the name of sport.

The story of the Arctic is much more, and much other, than the story of geology and geographical and ethnographic research, more than the story of national interests, from territorial politics to whaling, more than the story of the environment and the climate. It is one of our great, fundamental cultural narratives, the story of our culture expanding and evolving through images that mirror the familiar in the unknown, and the story of how these images are far more active than we might think – accordingly, even contemporary art has been picking Arctic narratives back up.[27]

In the 19th century, desire and image are impossible to distinguish from the real Arctic. This great yearning for the unknown, for the new, for a place no one has ever been, could just as well be the formula for what so much art is as for what drives expeditions to the absolute North. "Going north," at heart, is a cultural project born of images and itself giving birth to new images of the human position in the world. ‡

Poul Erik Tøjner (b. 1959), director of the Louisiana Museum of Modern Art since 2000 and curator of ARCTIC.

1 The Arctic, in classical antiquity, is defined as a region, not a pole, specifically, the region from which the constellation Ursa Major can be seen, cf. Minik Rosing's essay *Clarity in the North* in this publication. 2 Simon Schama, *Landscape & Memory*, London 1995. 3 Peter Davidson has written a brilliant book mapping out this cultural or psychological drive to go north. Like many others, he was inspired by the Canadian pianist Glenn Gould's famous radio montage *The Idea of North* from 1967. Everyone carries an idea of North, Davidson says, cf. *The Idea of North*, London 2005. 4 The proto-Nazi Thule Society in Munich, whose members at the end of World War I included Hitler, Rosenberg and Hess, claimed that Thule existed as the home place of an original Aryan race, cf. Joanna Kavenna, *The Ice Museum – In Search of the Lost Land of Thule*, London 2005, p. 133-167. No less grotesque is the New Age prophet Dr. Tunalu of the Institute of Druidic Technology, who believes that Stonehenge is a linkup to a supercomputer under the North Pole, cf. Peter Davidson, op. cit. p. 25. 5 Cf. Roland Huntford *Nansen*, London 1997, p. 74. 6 Cf. Francis Spufford's excellent description in *I May Be Some Time: Ice and the English Imagination*, London 1996. 7 Davidson, op. cit., p. 51. 8 Robert McGhee, *The Last Imaginary Place: A human History of the Arctic World*, Chicago 2005. 9 An encyclopedic survey of frequency and objectives is provided by *ARCTIC Exploration and Development, c. 500 B.C. to 1915: An Encyclopedia*, New York & London 1994. The chief work, though, is Matti Lainema and Juha Nurminen's lavishly produced and illustrated *A History of Arctic Exploration: Discovery, Adventure and Endurance at the Top of the World*, London 2001. 10 McGhee, op.

cit., p. 239. 11 Chauncey C. Loomis uses the word "trope": "Most eighteenth-century writers were ignorant of the Arctic and of Arctic narratives; in their work it became a mere trope, a convenient source of stock phrases about 'icy grandeur.'" "The Arctic Sublime," in U.C. Knoepflmacher and G.B. Tennyson, *Nature and the Victorian Imagination*, London 1977, p. 97. 12 Simon Schama, op. cit., p. 61. 13 The world of the Inuit cultures is more so the one in which they simply live, while the issue is more complex in societies that build nations. The idea of North plays an altogether different role in Canada, where culture and art are exceedingly challenged by the fact that more than a third of Canada is practically inaccessible, cf. Sherrill E. Grace, *Canada and the Idea of North*, McGill-Queen's University Press, 2001. 14 Cited from Spufford, op. cit., p. 101. 15 Cf. Johannes Grave, *Caspar David* Friedrich, Munich/London/New York, 2012, pp. 187-206. 16 Cited from Spufford, op. cit., p. 93. 17 Cf. the classic text on the subject, Chauncey C. Loomis, "The Arctic Sublime," in U.C. Knoepflmacher and G.B. Tennyson, *Nature and the Victorian Imagination*, London 1977. 18 The starting point for Diana Donald's reading of Edwin Landseer and Briton Riviere, in "The Arctic Fantasies of Edwin Landseer and Briton Riviere: Polar Bears, Wilderness and Notions of the Sublime," *Tate Papers*, Spring 2010. 19 Russell A. Potter, *Arctic Spectacles: The Frozen North in Visual Culture, 1818-1875*, Seattle & London 2007, p. 160. 20 Russell A. Potter, op. cit., p. 7. 21 Eric G. Wilson, *The Spiritual History of Ice – Romanticism, Science, and the Imagination*, New York 2003, p. 141. 22 Wilson describes this whole complex. A key witness is the American poet and author Ralph Waldo

Emerson, whose "snowy gnosis," i.e., what you might call his "cognitive theory of ice," deserves to be quoted in full, because it, in a crystalline (!) way, contains the gamut of the philosophical meaning of ice in the mid-19th century: "Staring into the frozen shapes, Emerson's speaker experiences a fourfold revelation. First, he understands that ice is alive, a vigorous manifestation of an abyss of being, transcendent (beyond the limitations of space and time) and immanent (flowing through wild geometries). Second, he realizes that the snow crystals are polar – chaotic and calm. Third, the speaker recognizes a natural poetics. The world's forms are coincidences of opposites, marriages of centripetal and centrifugal energies. Fourth, the ice – as paradoxical image of boundless energy – is sublime, a disclosure of mysterious powers that mock egotistical desire while inviting the unselfish artist to merge with their frosts," p. 31. In European literature, as a similar example, one could mention the transcendent skiing of Hans Castorp, the protagonist of Thomas Mann's *The Magic Mountain* (1924). 23 Henry David Thoreau, *Walden; or, Life in the Woods*, New York 1995, p. 207. 24 Pierre Berton, *The Arctic Grail: The Quest for the Northwest Passage and the North Pole, 1818-1909*, New York 1988, p. 312. 25 A great loss of respect for animal life and landscape likewise takes place, most apparent in overhunting, e.g., of polar bears, which were shot for sport from passing ships by Arctic tourists who had nothing better to do, cf. Barry Lopez, *Arctic Dreams*, New York 1986, p. 111. 26 Bruce Henderson, *True North: Peary, Cook, and the Race to the Pole*, New York/London 2005, p. 37. 27 Cf. Matthias Ussing Seeberg's essay in this catalogue.

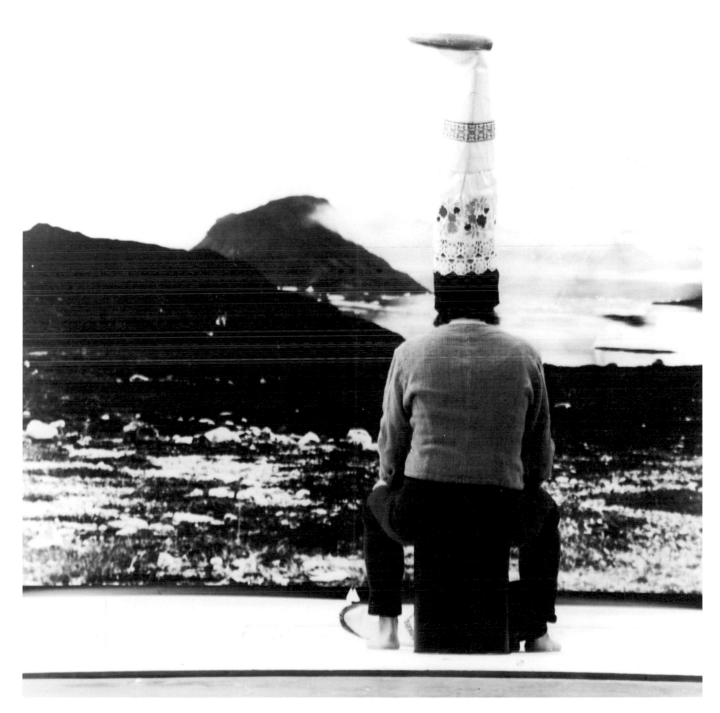

PIA ARKE

Untitled (Put your kamik on your head, so everyone can see where you come from), 1993
B/W photograph of Pia Arke in front of a photostat of a pinhole camera photograph of
Nuugaarsuk Point, Narsaq, wearing a Greenlandic woman's ceremonial kamik boot
on her head, 12.6 x 12.6 cm

GERHARD RICHTER

Eisberg, 1982
Iceberg
Private Collection

GERHARD RICHTER

Eis, 1981
Ice
Oil on canvas, 70 x 100 cm
Lent by Ruth McLoughlin

33

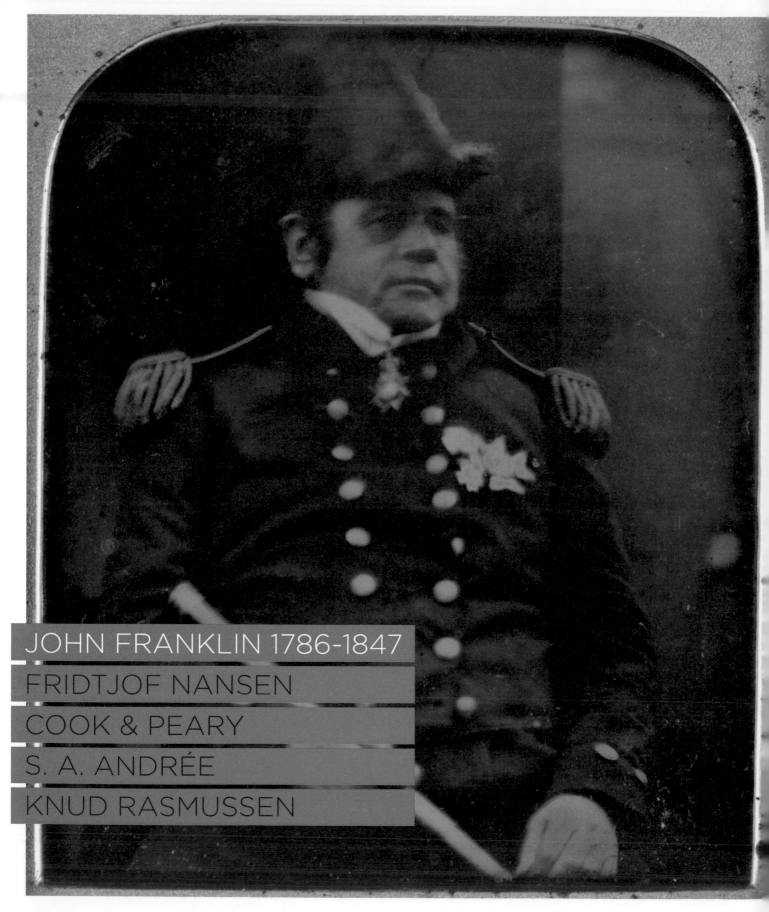

JOHN FRANKLIN 1786-1847

FRIDTJOF NANSEN

COOK & PEARY

S. A. ANDRÉE

KNUD RASMUSSEN

Because he disappeared ...

SIR JOHN FRANKLIN is famous because he disappeared and was never found. After two expeditions over land in 1819-1822 and 1825-1827, the first of which ended in disaster with loss of human lives, he set off on his last expedition with the ships HMS *Terror* and HMS *Erebus* in 1845. He and his two ships were last seen in the Arctic area on 25 June 1845. End of story ...

The story of Franklin is the gloomy but also grotesque tale of two important elements in Arctic expedition history: first, the belief that the culture of the homeland could also prevail in the unknown; secondly, the sense of collective responsibility that in many ways united the British public in the search for the lost hero.

As for the first element, it was as if a small theatrical company had set off in *HMS Terror* and *HMS Erebus*. What they were to perform was a vaudeville about the universality of the values of Victorian England – that is, the expedition was to confirm that the British value-set is the first natural choice everywhere in the world. This was of course inherent in the thinking of the Empire: what was the point of subjugating the whole world if everything out there remained the same as before? So off went Franklin, armed to the teeth – but with knives and forks, so to speak: cutlery for several hundred men, ships' libraries for the dark times, organ music ... The idea was that in the freezing dark of the winter season a mini-society like the big one back home was to be maintained.

And back home was the domain of Lady Franklin. The ink on the marriage certificate was hardly dry when Sir John set off for the north, but Lady Franklin's devotion to her husband and later to her memory of him, and later still to 'his memory', was built up to Alpine proportions by his absence.

Franklin's mission was to find the North West Passage. However, this was a project that had no real economic interest, since the area was at all events unnavigable – passage or not; but they were willing to sacrifice a couple of ships and some crews on the symbolic altar of world domination. And above all they counted on powerful moral feedback to the nation that could master this trackless corner of the world.

Sir John Franklin could not. He got stuck and then sailed southward towards Canada and disappeared. No one ever saw him again.

Mother England sent out more than 50 expeditions between 1848 and 1859, and they searched everywhere except the place where Franklin had disappeared. The Admiralty demonstrated incomprehensible slowness and a lack of any pragmatic sense, while Lady Franklin proved an outstanding fund-raiser, and her own privately funded expedition did in fact succeed in finding traces that confirmed two quite central points: first, that

JOHN FRANKLIN
Portrait of Sir John Franklin, seated
and holding a telescope, 1845
Daguerreotype
Scott Polar Research Institute

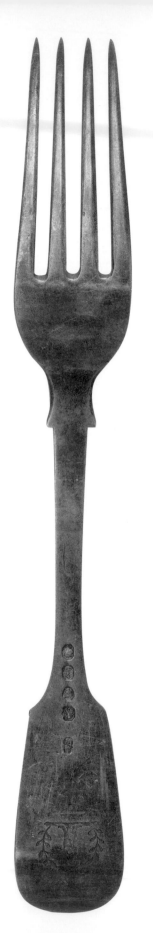
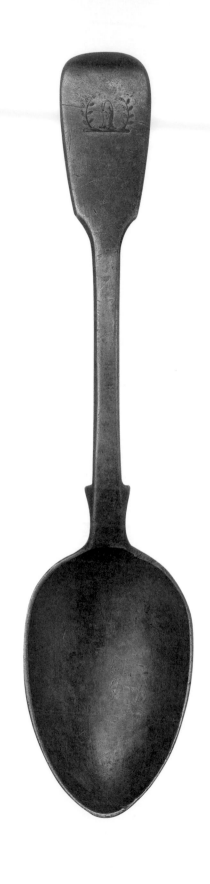

CUTLERY
Silver fork and spoon from Sir
John Franklin's last expedition
1845-48
The back of the handle bears
the Franklin coat of arms. It was
bought from the Inuit at Cape
Norton in 1859 by a party from the
McClintock Search Expedition.
National Maritime Museum,
Greenwich

the British crew had been totally incapable of ensuring its own survival, and appears to have resorted to cannibalism and other horrors – Sir Edwin Landseer's famous painting *Man proposes, God disposes* is a reference to this; and secondly, that Franklin had fortunately died before nature prevailed over nurture.

The search for Franklin was a drama that could spellbind a nation. All possible resources were used 'on location', so to speak. Messages were painted in enormous letters on mountainsides in the Arctic regions; stores of food and equipment were left at places where it was thought Franklin might pass; balloons were sent up, cannons and signal flares were fired; captured foxes were even given collars with messages for Franklin or his people – there was no question of discretion, this was a point of honour, it was communication. But it was to no avail.

In the end it made no difference, or at least very little. Of course it was terrible for Franklin and his people; of course it was terrible for his wife, although it appears that it became her mission in life to act both on stage and behind the scenes in the theatre of London opinion about the Arctic; but for Victorian culture it was of less moment whether you won or lost, it was playing the game honourably that was crucial. Noble failure could thus be the safest card to play, for then no one could suspect you of cutting corners and taking the easy way out.

By all indications Franklin's failure was hardly as noble as the national self-understanding required. Franklin's people died, one by one, worn out, incapable of procuring food, not least because their hunting traditions had only taught them to kill birds. They also died in an area inhabited by Eskimos, who however lacked the resources to feed passing Victorians. "They perished gloriously", *The Times* nevertheless wrote, insisting that the Arctic project was the great opportunity to test the cultural competence of society. But the test failed; and *precisely* because they took their culture with them when they set off from their British harbour. ‡

PET

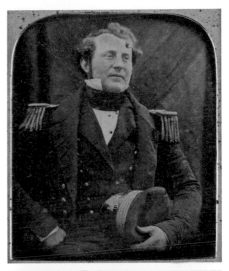

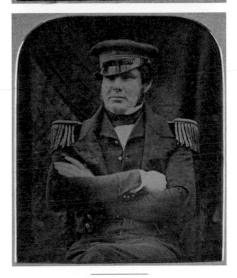

FRANKLIN'S MEN
James Fitzjames (top), Henry Thomas Dundas le Vesconte and Lieutenant James Fairholme, participants in Sir John Franklin's expedition 1845-48. Daguerreotype. Scott Polar Research Institute

The
Arctic
one-to-one?

The Arctic was one of the last places to be mapped in full – if such a thing can ever truly be done. There may not be a limit to the data collected on the areas mapped, but the decision of which data to use and when and where this data was collected is a determining factor in the image provided by these maps. There is always an underlying agenda.

Once, when the Arctic was still a far off, mystical place, there was a *terra incognita*, which explorers, scientists and artists travelled as best they could, giving free rein to their imagination and adventurousness, depicting their findings in stories, images, books and maps in an attempt to bring the globe's last unknown region into the known world. Today, in the 21st Century, news, images and maps from the Arctic region pour forth daily across the media, putting subjects like global warming, soon-to-be ice-free shipping routes and the ownership of land, sea, and natural resources high on the Arctic agenda.

In this new reality, the words 'terra incognita' to describe the Arctic are reduced to an empty metaphor. As Google Earth offers maps and satellite images of every inch of our planet at the click of a button, we seem to be approaching a point at which our map of the world is complete. Today's map of the world offers us a perfectly undistorted window on the world. Nothing is concealed. No blanks.

No undiscovered territory. Yet you need do no more than look back to the beginning of the 20th Century to realise that the absence of undiscovered territory in the Arctic region is a very new phenomenon.

Seen in a broader perspective, the removal of the last *terrae incognitae* from the Arctic map is the culmination of an exploration and colonisation of the world that has been dominated by Europe; one which has, over centuries, collated knowledge of diverse regions around the planet into a gigantic bank of geographic data. Through this process of abstract, fragmented and uncorrelated gathering of data, our view of the world has, in principle, become ever more complete and ever more precise. Against this backdrop, the historical development of cartography immediately stands out as a continual movement towards an ever more comprehensive, objective and empirically grounded and true description of the world, and we find ourselves at the initial apex of this today.

But the history of mapping is not only the tale of a gradual progression towards a complete documentation of the world's surface. In reality,

the idea of a complete and comprehensive graphic reproduction of the world is absurd, as the author Lewis Carroll highlighted in his fantasy of a 1:1 scale: "It has never been spread out, yet, [...] the farmers objected: they said it would cover the whole country, and shut out the sunlight! So we now use the country itself, as its own map, and I assure you it does nearly as well."

The scale in itself sets obvious boundaries on how much information a map can contain. But it does not determine which information the map can contain. Maps are not merely reproductions of more or less significant places in the physical reality of any given time period. They tell the story of phenomena and relationships that may, or may not, be directly observable, and which play a determining role in the map's ability to meaningfully locate humans in the world we live in.

An example of this is the very grid the map is oriented on, the network of latitude and longitude, which, despite the fact that is has no physical existence, constitutes what is possibly the single most fundamental element in modern cartography. The theoretical basis on which

the system rests was created in around 150 AD, by the Alexandrian geographer and astronomer Ptolemy, who collected the geographic knowledge of his time and described the principles behind the geographic determination of a given point on the Earth's surface. Ptolemy also devised instructions for the production of maps of the known world, with the necessary lists of topographic features, and titles for each map, though no actual maps from Ptolemy's time are known.

With the rise of Christianity in the Middle Ages, the Ptolemaic approach to geography slipped into oblivion in Europe. Even though many Medieval scholars acknowledged that the Earth was round, the world became less the focus of empirical intellectual observation, and was seen instead as a religious mystery. While such geographic elements as had been defined remained broadly static throughout the Middle Ages, the map of the world continued to develop almost exclusively in a literary sense, through a combination of imitation, fantasy, travel writing and orthodox Christian doctrine.

During the Christian Middle Ages, the Ptolemaic tradition was preserved and furthered in the Arab world, with refugees from the expanding Ottoman Empire bringing the tradition back into Renaissance Europe during the 15th Century. With the rediscovery of Ptolemaic geography came the introduction of a new way of ordering information on the map, which made it possible to understand, organise and describe the Earth and its surface with mathematical principles. Even though the content of the Ptolemaic map of the world began to seem increasingly anachronistic as a result

of the explorations of the following centuries, Ptolemy remained the founding authority in cartography right up until the end of the 16th Century.

AN ACQUIRED, MUTUAL UNDERSTANDING

The Arctic was one of the first regions that re-defined the boundaries of the map of the world, during the Renaissance, see fig. 1. Antiquity's knowledge of the planet's northern-most region was as good as non-existent, and the northern border of the Ptolemaic world lay at 60°N. But with the conversion of Scandinavia to Christianity, information about the geography of the area began to reach the rest of Europe. The first printed map of an area of the Arctic is attributed to Danish theologian Claudius Clavus (c. 1388 – 1455), who for many years lived in Italy, providing information about Greenland and the positions of a range of Greenlandic localities. Clavus had never been to Greenland himself, but his knowledge of Scandinavian journeys in the Arctic region made it necessary, in 1482, to expand the contemporary Ptolemaic map northwards, up to 74°N.

Even though new discoveries gradually extended the boundaries of the known world, and although it was not until 1884 that the countries in the Europeanised part of world agreed to lay the longitudinal meridian through Greenwich, the introduction of the grid system during the Renaissance created a new and highly functional cartographic paradigm. Today, this paradigm has become naturalised to the extent that its cultural nature has become almost invisible to us. That does not make it any less based, just like the contour lines in modern topograph-

ic maps, on a hotch-potch of cultural assumptions, standards and agreements.

The construction of the social structures surrounding the creation of maps – collection and registration of data, establishment of the necessary infrastructure of measurement points in the field, the development of observation techniques and instruments, and the training of qualified cartographers – involves a range of factors of fundamental importance not only for the cartographic project, but for society as a whole. In other words, maps show us an image of the world, so deeply embedded in our culture, that we, and the whole social environment around us, relate to it with overwhelming banality. Rather than a form that objectively corresponds to the real world, maps represent an acquired, mutual understanding between the cartographer and the map-user, making the map function as a 'true', useable depiction of the planet, and not merely an attractive combination of colours and symbols.

FICTIONAL WORLDS

Maps, then, do not only represent perceived and physical reality. Just as Magritte's picture of a pipe is not actually a pipe, a map is not a mountain, a river, or a real city. Cartography is a language, and individual maps are statements and opinions in a continued conversation about the world and our place in it as humans. And just as the meaning of words in a dictionary is defined by references to the meaning of countless other words, maps acquire meaning and authority on the basis of countless culturally-rooted ways with which to reference, formalise, select and categorise the world. Maps reflect

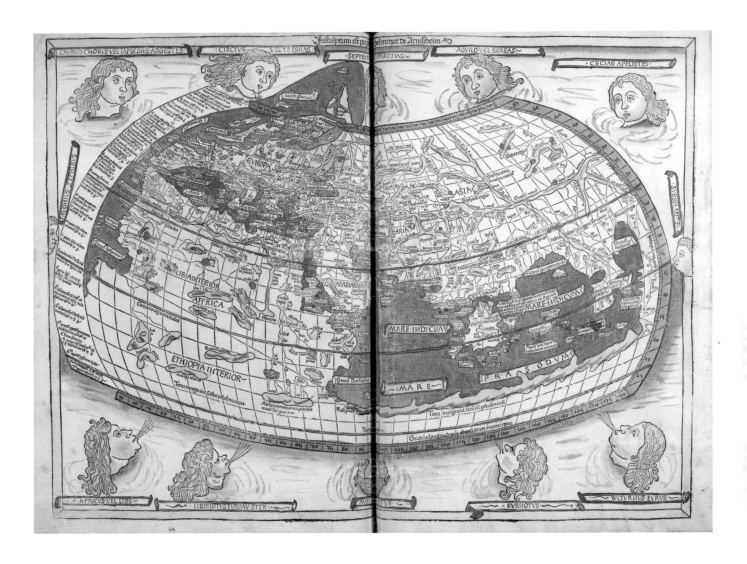

the assumptions and views with which we meet the world. They create and underline certain understandings of reality. And they shape our understanding of what is important, real and normal.

No wonder maps from other times and other cultures are often incomprehensible to us at first. But like other languages, maps are shaped by culturally-rooted rules, conventions and standards, which we, through attentive dialogue, can learn to understand, translate and use to expand our view of the world. An example of this is the carved wooden maps brought home by the Danish captain Gustav Holm, who, in the years 1884-85 became the first

European to visit Greenland's east coast around Ammassalik – see fig. 2. The maps were created by a hunter known as Kuniit, in the local style, and show the topographic features of the coastline, along a stretch of more than 100 km, to the north of Ammassalik: "He explained the map to me in all its details," Holm writes, "for example, by showing me how he had indicated that one would be able to carry a kayak over between the two fjords along the edge of a glacier, when the sea ice blocked off the headland."

And while Holm learned to read the Greenlanders' maps, the Greenlanders added information and explanations to the maps that

Holm himself drew and made use of. With the help of this information, Holm developed a new map of the part of the coast to the north of Ammassalik between 66° and 68°N, an area he himself did not explore. The map, of course, was drawn in conventional European style, with the use of Holm's own bearings and other available material. When the Danish captain Georg Carl Amdrup travelled the same coast in 1899-1900, he took

1. **PTOLEMAIC MAP OF THE WORLD**
Donnus Nicolaus Germanus, Ulm, 1482
Scandinavia and Greenland open up the
northern boundaries of the worldview
of Antiquity

the map with him, and found it so detailed and precise, that many of the settlements and islands featured were in exactly, or almost exactly, the correct geographic location.

The cartographic synthesis that arose from the dialogue between the hunter and the navy captain proved, on this occasion, to be fruitful. In any case for Amdrup. But the compilation of geographic information of differing nature and origin is a complicated process. This becomes clear when maps are viewed as provisional endpoints in an extended chain of historical processes.

2. **TWO WOODEN MAPS** showing the coast 100 kms north of Ammassalik, Eastern Greenland. Engraved by the hunter Kuniit from the Umiivik settlement in Ammassalik Fjord and sold to the Danish navy captain, Gustav Holm, in Eastern Greenland, 1883-85

The first detailed, printed map of the North Atlantic was produced in 1539 by the Swedish cartographer Olaus Magnus (1490-1557), based on maps of the region that, during the 16th Century, had been added to the Ptolemaic map of the world, along with traditional tales and myths about the North Atlantic region's geography – see fig. 3. Greenland was only partially included on this map, although it did contain a number of fantasy lands – including the island Frisland, which continued to feature on some maps of the North Atlantic as late as in 1808.

A particularly viable addition to the mythical geography of the North Atlantic was the idea of an area of mainland in the Arctic Ocean between Greenland and Asia. A central cartographic source behind that idea was a map published by

Nicolo Zeno in 1558, to illustrate an account of his ancestors' journeys in the North Atlantic in the late 14th Century, see fig. 4. The journey was alleged to have included a visit to Frisland, and the account and the map are still considered to represent a falsification based on maps and accounts from significantly earlier dates.

ARMCHAIR CARTOGRAPHY
Although the following 300 years' sailing of the North Atlantic later led to the erasure of the fictional islands, the idea of an area of mainland at the North Pole was maintained as late as in 1865, by the German geographer August Petermann, see fig. 5.

In the 1860s it was generally recognised that cold water ran south from the Arctic to the North Atlan-

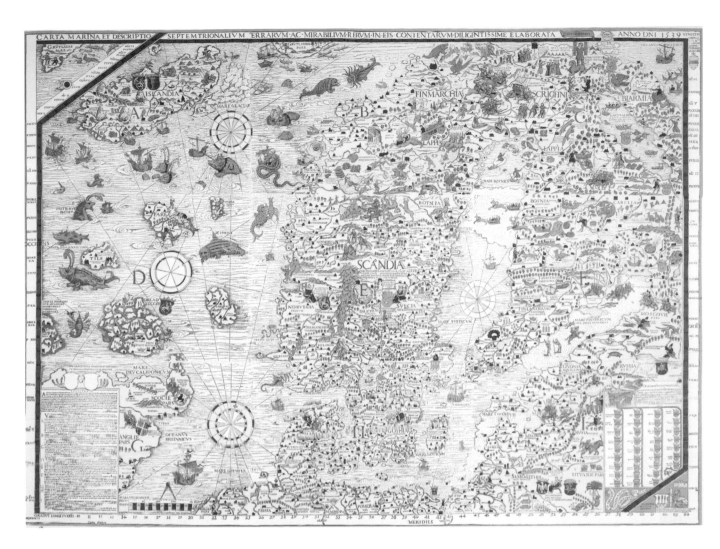

tis along two distinct channels: one between Greenland and the American continent, and one between Iceland and Greenland. The cause of the phenomenon was unknown, but two hypotheses dominated the discussion: one explanation was based on the existence of a powerful, but unidentified, ocean current in the central Arctic Ocean, and the other on the idea that the two channels were split by an unknown landmass positioned between Greenland and eastern Siberia.

Petermann himself never visited the Arctic, but spent time, in the way of many armchair geographers, producing critical studies of the works of others, in an attempt to reinforce his theory of a

giant peninsula that stretched from Greenland over the North Pole and into the East Siberian Sea. Despite the fact that Petermann, through these efforts, misinterpreted or overlooked a large number of results from contemporary explorations in the Arctic Ocean, his ideas took root, particularly in Germany, and prevailed until the start of the 20th Century. Not until the American explorer Robert Peary reached the northern-most point of Greenland were Petermann's theories finally disproven.

Yet Petermann was not completely insane. Even though the crop of land he had imagined did not exist as an actual landmass, his theories were to some extent confirmed in

1948, when Russian researchers discovered the underwater Lomonosov ridge dividing the Arctic Ocean – and the ocean currents in it, into two basins.

Petermann based his ideas about the geography of the Arctic Ocean on the comparison and interpretation of sources, circumstantial evidence and unreliable data of varying provenance, character and age. But this is a limitation we all share when trying to conceptualise and describe

3. **CARTA MARINA ET DESCRIPTIO SEPTENTRIONALIUM TERRERUM**,
Olaus Magnus (1490-1558),
Venice, 1539

4. **THE ZENO MAP**, Venice, 1558.
Printed as an appendix to a fabricated
travel account from 1390

5. **A MAP OF THE WORLD CENTERED ON
THE NORTH POLE**, August Petermann,
1865.
In 1865, the German geographer August
Petermann imagined a giant spit of land,
stretching up from Greenland to the East
Siberian Sea. Petermann's theory was
eventually disproved when the American
Robert E. Peary reached the northern-most
point in Greenland, Cape Bridgman,
in 1900

the world. Our knowledge of the
world consists primarily of ideas
and conceptions passed down to us
by others. Ideas which, through a
constant, historical process of refer-
encing, obscuring and overlapping
has achieved social acceptance and
canonisation in the giant geographic
database that constitutes our com-
mon knowledge of the world.

A MAP IS A VIEW POINT
AND AN AGENDA

Today, the illusion of homogeneity
and simultaneity of geographic data
is almost complete. With the help of
satellites and computer technology,
we are now in a position to create an
image of the Earth that is in every
way more precise and complete –
and even true – than has been pos-
sible at any other time in the history
of the world.

Tom van Sant's ground-breaking
satellite maps of the Earth, from
1990, gave us an image of our planet
that was so realistic that any ques-
tion of authorship, incentive and
cultural background seemed irrele-
vant – see fig. 6. Here we apparently
have an image of the Earth, just as
we would see it if we ourselves were
floating in space. But no – it is not
so! Gordon Cooper, who was an
astronaut on the last Mercury flight
in 1963, said that he was able, from
his space capsule, to see things like
trucks on dry roads, railways and
the smoke from buildings – none of
these things can be found on these
images, not even with the help of a
magnifying glass.

The satellites that – ordinarily
at an altitude of around a thousand
kilometres – orbit the Earth approx-
imately every other hour, capture
large amounts of reflected radia-
tion that is invisible to the naked
eye. This is because distinguish-

ing between different geographic
elements, such as water, rock or
vegetation – but also factors such
as temperature and altitude varia-
tions – is easier outside the visible
spectrum. Data attributable to the
reflected radiation is encoded, inside
the satellite, into electronic signals
that are sent to the receiving stations
on Earth, where they are digitally
uploaded for analysis. This electron-
ic data is translated into countless
pixels, spread right across the radia-
tion spectrum.

A satellite image of an area of
around 160 square kilometres can
therefore consist of more than
30 million pixels. The processing
required to collate this data into
a coherent, meaningful image is
considerable: because a sequence
of images always bears traces of the
shifts in between, corrections may
be essential to ensure consistency,
the projection needs to be chosen,
and data captured in the invisible
wavelengths may need to be colour-
coded in the visible part of the
spectrum, etc. etc.

The data from which Sant's maps
are composed was collected at var-
ious times of the year over a period
of three years, in order to ensure
the best light, and the best vegeta-
tion! We are looking at an Earth on
which the southern and northern
hemispheres have summer simulta-
neously. The night's darkness never
falls, the clouds are carefully edited
away – the passing of hours and sea-
sons is neutralised. The images are
literally timeless. The Earth is ex-
posed. Nothing is secret. Everything
is made visible.

But this is, of course, an illusion.
No map can give a conclusive and
objective picture of the world – not
even the 1:1 map Carroll and others
have fantasised about. Every map

accentuates something and elides something else. It serves certain interests. This is not only unavoidable. On the contrary, it is the map's privileging of salient features over non-salient ones that makes it so useful and powerful as a tool for exploring, understanding, taking ownership of, and changing the world.

Today, global warming and environmental changes present new challenges for us up in the Arctic. While the sea ice and glaciers are melting, the thawing of the permafrost is effecting significant changes in erosion patterns across the surface of the Earth. Increasing seasonal variations in the Arctic may mean the colonisation of the region by non-native plants, fish and birds from the south, encroaching on Arctic species' territory. Simultaneously, hope is growing, in many Arctic nations – and their international trading partners – that the melting will bring economic advantages, in the form of new shipping routes and access to hitherto inaccessible natural resources – see fig. 7.

Through this process, the Arctic has gradually become the pivotal point in a complex mixture of scientific, environmental, political and commercial interests. We are flooded, as never before, by maps of the Arctic – maps that have wide-ranging agendas. In this context, it is now more important than ever to look at maps, not only as miraculous snapshots of reality, but as powerful, value-based statements in a discussion about the future of the Arctic that we must all take part in. ‡

Christopher Jacob Ries (b. 1963), M.A. in geography and history, PhD, research in history of science specializing in the history of geology, cartography and polar exploration.

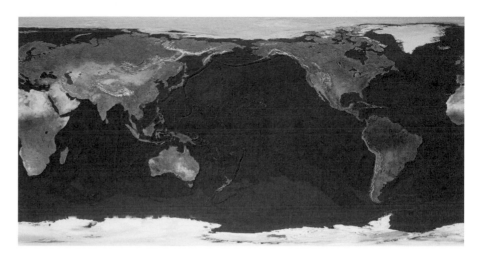

6. **THE GEOSPHERE IMAGE**
TOM VAN SAN, 1990. As the first satellite map of the world, it was a milestone in the history of cartography, and the best-selling image in the world since it was created. Since 1991, it was been used by all US federal agencies, the UN and reproduced in hundreds of atlases worldwide

7. **EVEN IN THE AGE OF SATELLITE MAPPING, THERE ARE BLANK SPOTS ON THE ARCTIC MAP**
Satellite map from Nimbus 7 showing the ozone layer over the northern hemisphere on 15 January 1986. The 1980 discovery of an annual depletion of the ozone layer over Antarctica – the 'ozone hole' – has led to fears that the Arctic may also be affected. The colours on the map represent Dobson units, a measure of atmospheric ozone. The black area over the pole is where no data was obtained due to the Arctic night

THORBJØRN LAUSTEN

Nuet – Det Polare Rum, 1996
The Present – Polar Space. Visualization of a Greenlandic
ice core, series of 37 drawings. Pencil, drawing ink,
watercolor on paper, c. 57 x 77 cm. Funen Art Museum

47

JOHN FRANKLIN

FRIDTJOF NANSEN 1861-1930

COOK & PEARY

S. A. ANDRÉE

KNUD RASMUSSEN

Rational romantic hero

IN MOST TALES of the Northbound journeys of the polar heroes, the beginning is a rather prouder affair than the end. They set off with pomp and circumstance – or less, if they do not have the funding in place or the great aspirations of the nation behind them. They undergo the most terrible ordeals on their journey – which is always different from what they planned – and then in the best case they come home with a sheaf of papers in their pockets, with islands and landscapes named to celebrate their discovery. Everyone – kings and newspaper magnates, brewers and other pillars of society – had islands, straits, basins and peaks called after them.

Fridtjof Nansen's adventure, on the other hand, is like a film that culminates in a final scene that lifts people out of their seats and sends them back into the world, enriched. One day, specifically 17 June 1896, after wandering around on the ice for eighteen months along with his assistant, Hjalmar Johansen, farther to the north than anyone else had come at the time, and now on the verge of disaster and giving up, Nansen hears a faint echo of dogs baying, suggesting the inconceivable good luck that there are other people nearby. He walks on by

FRIDTJOF NANSEN
Nansen smoking his pipe in front of Fram, 1895.
All photos from
Nasjonalbiblioteket, Oslo

himself, rounds an iceberg, and suddenly a man stands in front of him. Nansen tips his hat, wasteland or not, and says "How do you do?" Frederick Jackson, himself a polar explorer with tasks in the area, a ship and a crew, answers like any gentleman, "How do you do?" and continues, "I am damned glad to see you" – "Have you a ship here?" Nansen replies, "No, my ship is not here." "How many are there of you?" Nansen replies, "I have one companion at the water's edge." Jackson says, "Aren't you Nansen?" – "Yes, I am Nansen." "By Jove, I am devilish glad to see you." It is of course the meeting between Stanley and Dr. Livingstone at Lake Tanganyika in East Africa that forms the template for this dignified exchange in the middle of a freezing nowhere, but only in the light of hindsight. The calm that typifies Nansen seems quite disproportionate to the randomness of the whole event: you walk around the corner of an iceberg and there he is – your rescuer – and you can go home. Lucky you. If you had walked the other way you might have perished instead.

Nansen was a hero. A gifted hero, intelligent, and with both a scientific background and ambitions. He was also a handsome man, photogenic, with great charisma and integrity; in short he had all that was needed, on the one hand to overcome the scepticism of the surrounding world towards the polar adventure, and on the other to be canonized

afterwards. Not only did he put Norway on the world map; he also put Norwegian good sense and Norwegian technology on the local map. Nansen drew his inspiration for most of the polar expedition equipment from his own country's skiing culture – he was himself a magnificent skier – and learned the rest from the local Inuit in the Arctic. The Norwegian expeditionary culture that won the day for Nansen was far from the Victorian English fallacy that it was the homeland's values and their universal applicability that the polar adventurer was to demonstrate. Nansen had and retained a scientific, innovative character: he put his ear to the ground and listened. But he was also – and in the fullest sense – a romantic adventurer who was captivated by the dream. And after becoming the first man to cross the inland ice on skis it was naturally the dream of being the first man at the North Pole that set him off on his travels once more.

Nansen's main moves were in fact brilliant. The fundamental challenge for polar exploration was how high up you could reach by ship before you had to leave it and continue on foot. In reality the agenda for survival was very simple: the distance that had to be covered on foot had to be proportional to the equipment and provisions for both the journey out and the return to the ship – and it never was, because you could not get the ships in close enough. They froze into the ice before the ideal end of the

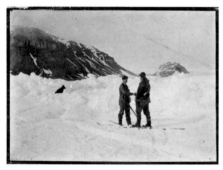

line – they became icebound. This was the great fear, for then it was just a matter of waiting until the spring and then going home again – that is, if the ship had not been crushed by the forces of the ice. Nansen's trick was precisely to turn this factor to his advantage, on the basis of a scientific observation: the remains of a ship had been found on the north-western side of Greenland, although it had been wrecked far to the east. This led Nansen to assume that the ice must drift from east to west, close to the North Pole, perhaps even right over it. So Nansen went so to speak voluntarily into the trap; he let his ship, the Fram, become icebound – and he could do so with calm assurance, because the ship, with its round belly designed by Nansen himself, had been tailor-made to pop up like a cork when the ice floes pushed together. A masterpiece of marine technology that later made the Fram sought after as an expedition ship – it was lent out for example to Roald Amundsen.

Everything succeeded – and yet not quite. The Fram froze fast and drifted and drifted, but not far enough north, so Nansen – and Johansen – decided to get off and continue north on foot. With inconceivable courage and great survival skills the two of them spent almost a year and a half in the monotonous landscape and reached farther north than anyone else before, but never to the Pole. For at 86° N Nansen decided, as the sensible man he was,

that to continue the journey towards the Pole would be unsound. The two men alternately walked and sailed in self-built kayaks across the Arctic Ocean, wintered in a home-made hut in the northern island group Franz Joseph Land, continued south towards Svalbard – and bumped into Frederick Jackson, who took them back with him to Norway on his expedition ship. The Fram itself drifted, with Otto Sverdrup as captain, as far as they had predicted, but farther to the south, from Siberia to Svalbard.

Besides the problem of ordinary physical survival, a calculated risk in the business, the two men's greatest problems were mental in nature. The long waiting time in the winter darkness, the isolation and the claustrophobic enforced togetherness in harsh circumstances (they had to share a sleeping bag) wore down their nerves and the cooperation that was necessary to survival. The pecking order – Nansen was boss, Johansen his subordinate – also affected their mutual devotion. But they survived and the world was able to welcome Nansen as a hero, seconded by reports and a number of fascinating photographs which in the best romantic style showed 'Man and Nature', gazing, dreaming, evaluating, using all his intelligence to get through the ice desert and onward. Nansen had been the first in the world to accomplish his expedition without loss of human life; he had documented that the

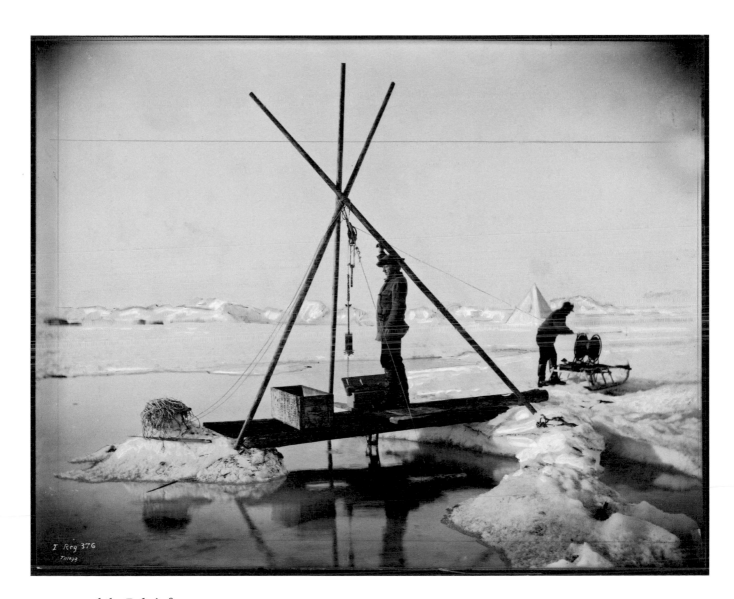

area around the Pole is frozen sea, and he was now the undisputed expert on ice. He had on the one hand proved the good sense of using small units for such expeditions, and on the other hand the good sense of using good sense as such. Nansen became the romantic rationalist. ‡

PET

ALEX HARTLEY

Nymark – Undiscovered Island, 2004
Victoria Miro Gallery, London

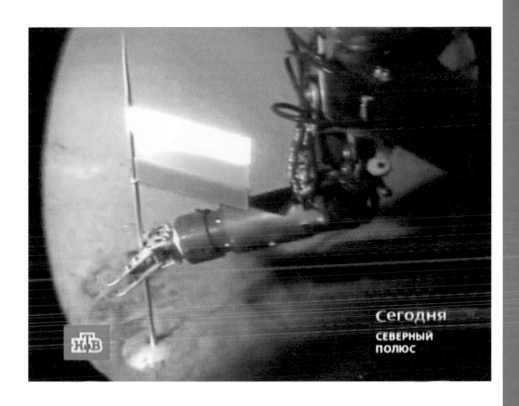

СегоднЯ

СЕВЕРНЫЙ
ПОЛЮС

—
MIR-I
MIR-I mini-submarine as it places a
Russian state flag at the seabed of the
Arctic Ocean at a depth of 4.261 metres,
2 August 2007

TRIVIA AT THE BOTTOM OF THE TOP OF THE WORLD

At the end of the 19th and beginning of the 20th century, a great number of
expeditions were sent off with the sole purpose of reaching the top of the Earth,
the geographical North Pole on the permanently frozen Sea of Ice. Historically,
expeditions to the Pole have been very little about mapping and science and
very much about personal ambition and the wishes of individual nations to de-
monstrate their supreme ability. One has to see the attempts to reach the Pole
in this light. When the American nuclear submarine USS Skate broke through
the ice at the North Pole in 1959, the event was of course filmed – otherwise it
would have made no difference to demonstrate the power. In recent years, as the
sea ice has begun to shrink drastically, the Arctic nations have set their sights
on significantly easier access to potentially endless riches such as oil and gas at
the bottom of the Arctic Ocean. This has led to a long succession of geopolitical
disputes over national boundaries, continental shelves and rights. In 2007 the
two Russian miniature submarines MIR-I and MIR-II dove 4.200 metres beneath
the surface of the sea at the North Pole and planted a one metre tall Russian flag
in titanium. The North Pole lives on as a symbol.

Heroes

Real polar heroes. Norwegian crime fiction writer, polar explorer and scientist Monica Kristensen investigates the myth-making of the arctic travellers. Maintaining an images as a polar hero is a lot of hard work.

*I*t is unavoidable: If we want to understand what a hero is, we must return to ancient Greek mythology. No wonder, perhaps. After all, the Greeks invented the word *hero* (græsk: 'ἥρωι) which means demigod. According to Greek mythology, a hero was the product of a fruitful encounter between a god and a human being.

The hero of Greek mythology was usually a man, although heroines were not unknown. What they all shared was that they had got their status solely from their parents. They could inherit many characteristics from both the mortal parent and the immortal one. The ancient Greek heroes had far less obligation to be particularly moral in their conduct than one expects from today's heroes. Nor was it necessary for the heroes of Greek mythology to perform deeds for the benefit of either gods or men. One thing was common to all the heroes of Greek mythology: They were just as mortal as humans beings.

Surprisingly enough, the concept of the hero has not gone out of fashion in today's high-tech world. Modern heroes have rather become more common than before. The realism – not to say cynicism

– that prevails in our time has not made the concept of the hero either old-fashioned or embarrassing. It seems that we modern people have a strong need to admire someone who is perceived to be a better version of ourselves. The hero concept is thus very durable. One may wonder whether it has a genetic basis since it has been around for so many millennia. Can the almost natural admiration for the hero's qualities be necessary for the human species' assumption of a dominant role on the planet? Can it be that *all* people carry within themselves an urge to bring forth their inner hero and that people are aware that this condition can be achieved only by exposing themselves to forces or powers that initially may seem invincible?

THE MODERN HERO

In present-day society, we find the hero in almost all aspects of life. It seems as though we all know exactly what a hero is, how he must behave, what kind of ethics comes with such a title. Indeed, we are inundated with the hero label – in film, in literature, in the media, in everyday speech. Heroes are our secret religion regardless of socioeconomic status, race and nationality. The cultivation of special people seems to indicate an urge to admire

individuals who are perceived to be more proficient, more moral, more able to perform heroic deeds. There seems to be a strong belief that we humans can be divided into "ordinary" and "extraordinary" mortals. In addition, there is a perception that heroic qualities are innate but in some cases must be awakened by distinctive challenges. The hero may therefore not be identified by his appearance, and a modest demeanour can often mask the characteristics and patterns of behaviour that later make that person visible as a hero.

The hero's characteristics can be summarised as follows: He was born that way but must often be subjected to inhuman challenges to activate his heroic qualities. Mortal, but with an innate ability to touch the immortal. He has qualities that approach the supernatural. A strong urge to perform feats beyond human endurance.

THE ERA OF THE POLAR HERO

Of all heroes, there is a special aura about polar heroes. Few others have been praised and surrounded with enthusiasm as they have, perhaps with the exception of the astronauts in the 1960s and 1970s. But there are also many similarities between the two groups. They struggled against natural conditions hostile

to humanity; they were put to the most extreme tests in an environment that was dangerous and at the same time beautiful and captivating. Polar heroes moved in the borderland between myth and reality, between the living and the dead. In many ways, their achievements can be compared to those in the heroic Greek sagas of the fantastic journeys of Heracles, Odysseus and Jason and the sailors on board the ship *Argo*.

The polar heroes had their heyday from around the beginning of the preceding century right up until the 1960s. This period has since been called an age of heroism. The end came when people started to travel in an even more dangerous area – outer space. The great polar expeditions faded in people's admiration after the new heroes – the astronauts – became the object of an enthusiasm approaching hysteria. One of the last polar explorers, Sir Walter (Wally) Herbert, experienced this when he and three companions on an expedition, after inhuman travails, reached the North Pole on 6 April 1969. They travelled a total of more than 6.000 kilometres across the frozen sea, from Alert, Alaska, to Vesle Tavleøya in the Svalbard Islands – one of the longest and hardest polar expeditions ever made.

This event should have been on the front pages and hailed in the media around the world. That is, if the preparations for mankind's first moon landing by the American *Apollo 11* spacecraft had not been in full swing. Wally Herbert came to Svalbard on 16 June and returned to the UK around the same time that Neil Armstrong jumped down on the surface of the moon and said, "That's one small step for man, one giant leap for mankind." Wally

Herbert's achievement was thus overshadowed by the moon landing. He was never worshiped as former polar heroes had been. To his great sorrow, he was not knighted until the year 2000.

When I met Sir Wally for the first time in 1979 as a young student in Cambridge, in all our conversations he exhibited an underlying pessimism and ill-concealed bitterness. He felt he had missed out on a hero's recognition because he had performed his greatest achievement at the wrong time. He did not gain the admiration and honour he had expected were rightfully his. None of his later expeditions in the polar regions aroused the public's interest to the same extent.

He was not alone in meeting this type of adversity. Even the greatest of polar heroes, the one who achieved the most spectacular results in both the North and the South – the Norwegian polar explorer Roald Amundsen – died disappointed and on the verge of bankruptcy.

ROALD AMUNDSEN

As a young man, Amundsen experienced the overwhelming tribute paid to Fridtjof Nansen when Nansen returned to Norway in the summer of 1889 after crossing Greenland on skis along with five other expedition participants. Since Amundsen described it in his book *Mitt liv som polarforsker* (My Life as a Polar Researcher), we know that the tremendous cheers from the crowd upon Fridtjof Nansen's homecoming in Oslo Harbour were such a powerful experience for the young Amundsen that he decided at that moment to become an explorer of the polar regions himself. He completed his medical studies,

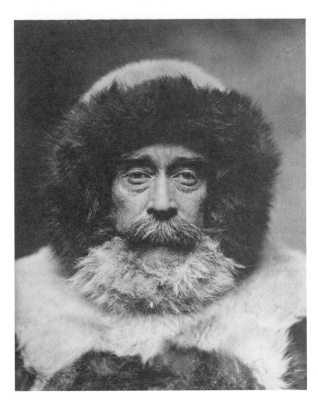

years later, and began the laborious preparations for his coming career as a polar hero.

The timing was right in his case. Other explorers could tell stories about fairytale landscapes, of achievements and terrible trials in jungles, rain forests and deserts. The source of the Nile (Lake Victoria) had been discovered in the 1850s; the Sahara and the interior of Africa were explored over the next decades by explorers including David Livingston and Henry Stanley. In Amundsen's time (the beginning of the 20th century), Mount Everest had not yet been climbed, but there were few large, unknown territories left to conquer. The polar regions, however, were still unknown. These inaccessible extremes held an almost magical attraction for the popular imagination. The explorers who tested themselves against the ominous natural forces at the poles were admired with a frightening intensity.

THE ARCHETYPICAL HERO

Joseph Campbell, the American author born in 1904, wrote many books on comparative mythology in which he analysed the function of the cult of the hero. In Campbell's opinion, the hero was an important part of society and also of one's own development. Campbell believed that the archetypal patterns he seemed to find among heroes from all civilisations served to strengthen the ties between the individual's personal realisation of inner qualities and the role the individual plays in real life.

In his book *The Hero with a Thousand Faces,* from 1949, Campbell describes what he calls "the Hero's Journey" through a series of challenges – "the Twelve Stages" – that lead him from ordinary reality to the status of a permanent hero. Central among these stages is the notion that the hero must conquer death in order to return to reality. The path back from great deeds is

ROBERT PEARY
Portrait by Byron Company, 1909
Museum of the City of New York
USA

MONICA KRISTENSEN
Portrait by Lord Snowdon, 1989
Lord Snowdon and Condé Nast

thus an important part of the hero's development. In many ways, the author describes concepts that had already existed in the Greek heroic legends, for example the idea that the hero undergoes a transformation through rituals.

Campbell's descriptions are fascinating – and very useful for writers, filmmakers and other creative professionals. But they are bad news for the hero himself. It may well be that the polar heroes' expeditions are consistent with the twelve stages that gain them status and admiration. But Campbell forgot to say what happens afterwards. What becomes of him, this hero, in the modern world, with such a short time span between news events and so many self- styled competitors in the hero business? Is he sitting at family gatherings as an endlessly reminiscing nuisance to his grandchildren? Does he rage against the fast pace of contemporary life and the forgetfulness that occurs when the next hero comes on the scene?

STAGED PHOTOGRAPHY

Harald Østgaard Lund and Siv Frøydis Berg, in their wonderful book *Norske Polarheltbilder 1888 til 1928* (Images of Norwegian Polar Heroes 1888 to 1928), published in Norway in 2011, shows, among other things, how the use of photographs helped create the image of the polar hero – and how the polar explorers themselves contributed to this. Many of these iconic images were taken in demanding conditions and with great difficulty at the places they depict. Scott's and Amundsen's pictures of the tent at the South Pole in 1911 and 1912 are some of the most famous in polar history – not least because they so clearly show the difference between the two expeditions and offer a warning about the suffering that awaited the Englishmen.

Yet the most interesting part of the book is the photos that show how the contrived, far from authentic motifs had a life of their own. What do the pictures show about the heroes' own contributions to the adulation they experienced?

To my great surprise, I was also depicted in the book, included in a distinguished collection of portraits – in a very selective section consisting of three iconic hero images. There I am, gently smiling between Robert E. Peary from 1909 and Roald Amundsen photographed in Alaska in 1920. As far as I can see, I am the only one of all those portrayed who is actually still alive. It is therefore possible for me to say a few things about the circumstances of my own photograph, which was taken by Lord Snowdon – about the staging, the background, the design, and what later happened to this picture.

I did not know of *Vogue* magazine, which had commissioned the photograph. I had no idea who the stern woman was who was flitting around me with make-up trying to make me look 'natural'. It was Anna Wintour, I have since been told. I was dressed in a huge coat made of reindeer skin borrowed for the occasion from a museum in London. It had an unbearable smell of rancid fat and old dust. I was stuffed into a hood, as befits a polar hero. Over one shoulder, I had a heavy bundle of ropes hastily borrowed from a construction site nearby. At my feet lay a very old polar dog panting in the summer heat. Lord Snowdon was a pleasant, charming man and a skilled photographer. The photograph was of course good, more than good. It was iconic. But it had nothing to do with the expedition to the South Pole we would soon embark upon. I posed for the picture because I was well paid for it and the expedition needed money.

THE DUTY OF A POLAR HERO

As far as I know, Roald Amundsen and Robert Peary did not comment on the studio photos of themselves. A man of Amundsen's stature must have felt rather humiliated as he lay sprawling in the snow on the frozen Bunne Fjord outside Oslo, dressed in a leather jacket that would have been too hot even at the South Pole. We can only guess what the heroes may have had as intentions, ulterior motives or hopes with such posturing. On the basis of my own experiences in Lord Snowdon's studio in London, I would suppose their thoughts probably revolved around fears of failing to achieve their ambitions, dreams of success and living up to the heroic images. But most of all, financial problems were probably the driving force for the various PR offensives. Appearing before the public as a genuine polar hero was probably just a necessary part of their work, a duty, even for them.

A brief anecdote told to me many years ago by the Norwegian philosopher Peter Wessel Zapffe illustrates this. Peter was the son of Fritz Zapffe, a pharmacist in Tromsø and Roald Amundsen's greatest admirer and perhaps his best friend. When Peter was a child – he was born in 1899 – he often met Roald Amundsen. On one occasion, after Amundsen's return from the South Pole, the polar hero was visiting late one night after a lecture tour. People in Tromsø had learned that Amundsen was in town. They gathered outside Zapffe's house on Storgata street, cheering and singing and waving Norwegian flags in

the slushy, freezing road that late evening.

Amundsen got ready to go out on the balcony and receive their tribute. "But must you really do this, Roald?" asked Fritz Zapffe, concerned about his friend. "Let it go. You are tired, and I can go out and say that you have gone to bed."

According to Peter, Amundsen sighed deeply and shook his head: "No, it must be done. Otherwise they will be so disappointed."

With his exquisite sense of humour, Peter thought this episode was incredibly amusing. Out there in the autumn darkness and cold were a hundred people who had made a great effort to come and give Roald Amundsen the pleasure of their homage. But Amundsen felt that, far from enjoyment, it was a heavy burden to accept their tribute. On many occasions, Peter said that he thought Amundsen was a bit of a show-off.

The anecdote also tells us something else. It reveals a little about all the duties that the polar heroes voluntarily undertook in order to be worshiped. Being a hero is a job. It is not acceptable to have a bad day. The hero has signed a contract with his adoring public – to live up to the myth of the fantastic achievement, of the inhuman effort. Presumably, the ties between the hero and his followers were created long before man visited the polar regions. They testify to a need of the social human species.

MYTHOLOGY
Roald Amundsen disappeared somewhere near Bear Island on 18 June 1928 while searching for an Italian polar hero and rival, Umberto Nobile, in a seaplane. This is the conclusion of Fridtjof Nansen's beautiful eulogy in his honour:

"And then, when the work was done, he returned to the expanse of the Arctic Ocean, where his life's work lay. He found an unknown grave under the pure sky of the ice world, with the presence of eternity throughout space. But in the great white silence, his name will shine in the bright Northern Lights for Norwegian youth for centuries. It is men with courage, with determination, with strength like his who give us faith in the race and give us confidence in the future – A world that fosters such sons is still young."

No one can deny the seductive, myth-making poetry of Fridtjof Nansen's eulogy. But truthful it is not. For many years before he died, Amundsen struggled with poor finances, personal and scathing criticism in the newspapers, a sense of failure despite all the glorious expeditions with successful outcomes. We know this because we have the letters he sent to his friend, Zapffe the pharmacist. There we read that the polar hero embarked on lecture tours that were sparsely attended because the far more exotic Umberto Nobile had been to the same places before him, about how he harvested apples on his property in Svartskog to sell at the market in Oslo. Even that brought little profit because it was a good year for growing apples and everyone had their own trees to harvest from.

Prosaic fragments of an ordinary human life. There will be no veneration and worship of things like that. Only when Roald Amundsen disappeared without a trace in the white, barren Arctic did he find his way back into the icy, glittering world of myth and become a hero. ‡

Monica Kristensen (b. 1950), Norwegian glaciologist, meteorologist, polar traveller and crime writer, educated at the universities of Tromsø, Cambridge and Oxford. Has completed several successful expeditions and research stays on Svalbard and has published many crime novels.

TRIVIA FORTRESS OF SOLITUDE

The Arctic landscape is not for everyone. Perhaps it is for that very reason that it has appealed so particularly to men who wanted to be heroes, and there have been many heroes in the Arctic: from Fridtjof Nansen to Robert Peary to Knud Rasmussen. But there is one who surpasses them all. In the first Superman film with the title *Superman – The Movie* (1978), directed by Richard Donner, we meet the young Clark Kent on a journey through a snowclad Arctic landscape headed for the North Pole. With him Clark Kent has a crystal from his home planet Krypton, which was destroyed by an asteroid shortly before Kent was sent to the planet Earth by his parents, who had foreseen the disaster. When the young Clark Kent reaches the North Pole, he throws the crystal across the desolate landscape. The crystal lands on the ice and melts into it, and then an enormous crystalline edifice comes thundering up through the ice: *the Fortress of Solitude*. Inside the fortress there are memory crystals that help Kent to remember his past and his parents, and to learn more about who he is; it is a place where he can be in peace and alone; a hermitage for the world's strongest man. The Fortress of Solitude is in a landscape regarded by most cultures as unsuitable for human habitation; an almost unearthly place where only an extraterrestrial being, perhaps a man of steel, could feel at home. The Arctic is a place for heroes.

TRIVIA **THE SNOW BABY**

It sounds like Hans Christian Andersen, but the Dane had already written *The Snow Queen* by the time Josephine Peary, lawful wedded wife of the polar explorer Robert Peary, began her little book, full of photographs, about the arrival in the world of her little daughter Marie in 1893 in North East Greenland, with these words: "Hundreds and hundreds of miles away in the white frozen north, far beyond where the big ships go to hunt huge black whales, there is a wonderful land of snow and ice, mountains, glaciers, and icebergs." AH-NI-GHI-TO, that is 'Snow Baby', is what the local population call the little girl with blue eyes who grows up there – for Josephine wasn't one of those wives who stayed home; she insisted adamantly on following her husband, more or less to the ends of the earth. That she also learned that he had more children in the north doesn't seem to have lessened her love of the country; for Josephine described the Arctic in its summer bloom with an enthusiastic feeling for flowers, scents and colours. Her tale shuttles between Wonderland and her home in America, where the Snow Baby, with great surprise, gets used to another world.

MRS. PEARY AND MARIE
Anniversary Lodge, 1894
Josephine Diebitsch Peary's scrap
book, Josephine Diebitsch Peary papers
Maine Women Writers Collection University of New England, USA

TAVARES STRACHAN

Standing Alone, 2013
Digital duratrans prints, light boxes
237 x 30 x 3 cm. Courtesy the Artist

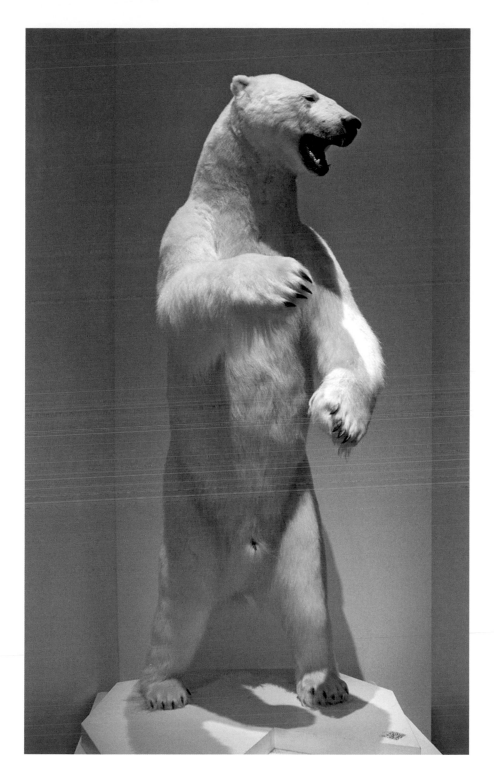

TRIVIA POLAR BEARS

The polar bear is an intelligent, technologically advanced animal. The outermost hairs of its fur are hollow and function as cables that conduct the heat of the sun into the animal's body. It gets rid of the heat again through the claws and pads on its feet. When it hunts, it's a trickster – and a cool killer. Eskimos tell us about the polar bear's tricks: it throws lumps of ice at the walruses to lure them away from their young, so they lie there unprotected and ready for the bear to help itself. When the polar bear is hunting for seal meat, it sometimes builds a rampart of snow that it hides behind. Other times it lies in wait at the seal's breathing hole in the ice for hours, and approaches with the front part of its body sliding on the ice so the seal won't see the horizon line between the bear's legs. The social life and communication of the polar bears is a mystery. They are wandering recluses, but when a polar bear finds a good food source. it isn't long before ten to fifteen other bears appear – and they have come a long way. Scientists are amazed by their gastronomic intuition!

STUFFED ICE BEAR
270 x 175 x 150 cm
Natural History Museum
NATURAMA, Svendborg

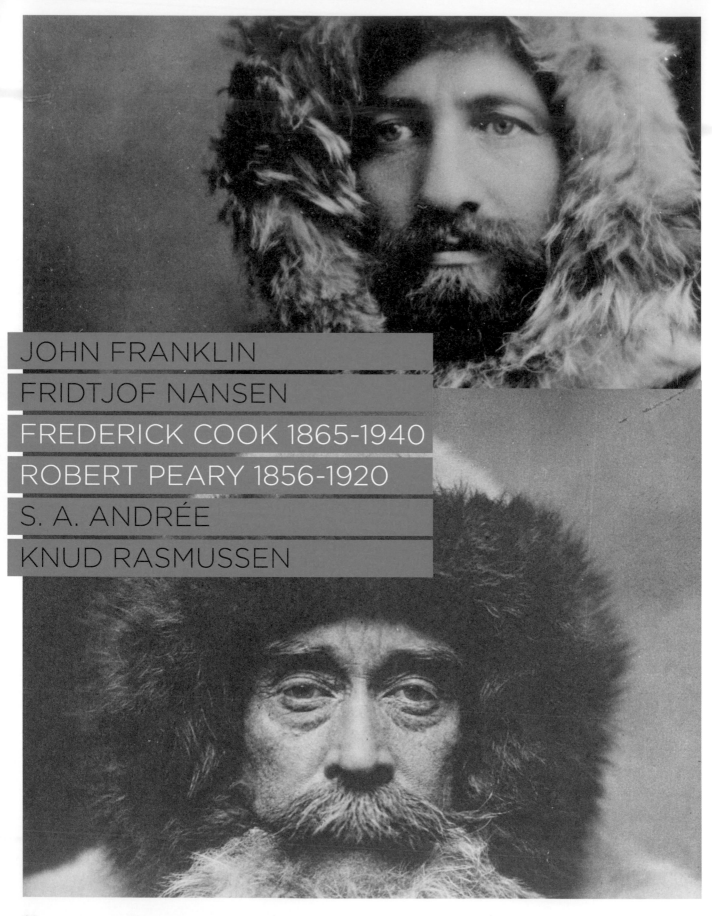

JOHN FRANKLIN

FRIDTJOF NANSEN

FREDERICK COOK 1865-1940

ROBERT PEARY 1856-1920

S. A. ANDRÉE

KNUD RASMUSSEN

The American way

IT WAS NOT A MATTER of indifference to Fridtjof Nansen whether he could be the first man to reach the North Pole – and yet he devoted as much talent to the technique he used and the way he approached the whole affair as to the actual bid for the Pole. To complete and survive an expedition to the North was in itself a tour de force for the Norwegian. With Frederick A. Cook's and Robert E. Peary's arrival on the Arctic stage, *American* virtues now took pride of place – Victorianism's noble satisfaction in simply playing the game was now superseded by a crystal-clear goal: it was all about winning. Anything less was uninteresting. Only the person who reached the North Pole first had any claim to fame, and Peary had after all already written in a letter to his mother early in his career: "I must have fame"! To be number two was nothing, although reaching the North Pole at all still had to be described as a quite extraordinary achievement at the beginning of the twentieth century.

The story of Peary and Cook is a sad and parodic one. It begins with something like a friendship and ends in unrelenting trench

warfare, in reality with two losers. Officially it was Peary who carried off the victory – but to this day there is relative agreement that *neither* of the two combatants is likely ever to have reached the Pole, and agreement that if one of them did, it was more likely Cook.

It began in fact with mutual respect in a shared cause. Cook, who was a doctor, joined one of Peary's first expeditions to the north and became Peary's rescuer in connection with an accident that could have disabled him. Peary thus had Cook to thank that he was at all able to carry on, but gratitude was not a phenomenon that featured strongly in the Pearyan mentality, where we instead find insane ambition coupled with a possessiveness approaching psychosis – Peary quite simply thought that he had a monopoly of the right to reach the North Pole first. This was thus the gamesmanship of the New World, but mixed with the aristocratic privileges of the Old World.

The matter was simple – and the aim quite clear. In April 1909 Peary set off on his last expedition to the North Pole – which in his own opinion was successful. At the very same time Cook travelled from Upernavik in Greenland to Copenhagen to tell the world that he had succeeded in reaching the Pole – in April, in fact, but the preceding year, in 1908. In the Danish capital Cook was received by the King and the University, Knud Rasmussen,

Peter Freuchen and the world press. He was celebrated with a great public banquet, although right from the start questions were asked about the validity of his claim – which was later rejected by the University. For Cook had left his notes and instruments in Greenland, where they disappeared, never to be found again. His answer to the world press is interesting, for he said, "Why don't you take my word for it? Neither Nansen nor Amundsen presented anything but his own report on his own journey ..." – and that was true. Never before had the adventurers who went north been asked for documentation of their achievements; people trusted their word. Paradoxically, it was among other things Peary's smear campaign against Cook that set this new standard for the testing of their claims, and this affected Peary himself – or could have affected him – just as powerfully as Cook. For Peary too was unable to give a satisfactory account of his journey, and his observations were full of errors.

The battle between Cook and Peary was no longer a duel between two noble explorers – it was a modern story of sources and credibility. And as such it was of course played out in the media. The press was the new weapon and the battle was not only between Peary and Cook, but also between *The New York Times*, which sided with Peary, and *The New York Herald*, which was on

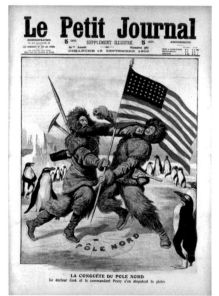

Cook's side. Peary knew all about publicity; every single contract he signed with his crews, from cabin boy to officer, had a clause imposing confidentiality on everyone, so that Peary himself could exploit everything they had experienced for his own gain. For this was now what one had to live on as a polar explorer when one got home: books, lecture tours and interviews. On the final tour to the North Pole Peary managed his crew such that he was the only white man in his company to reach the Pole.

Peary's true opponent, he thought, was Nansen. He raised money for his great project by appealing to American national feeling; the Americans did not feel comfortable with the fact that the Norwegian Nansen had gone farther north than anyone else. The Stars and Stripes were to be planted at the Pole; anything else would be unnatural. That Cook was also an American but made no contribution to any national pride from Peary's point of view only exposes Peary's totally rigid personal ambition – that and nothing else was his motivation.

The great trip up to the North Pole became a downer of vast proportions – Peary was a hard man, and Cook may have been a doctor, but he was no spin-doctor. Apart from the sensational and – perhaps for some – entertaining newspaper war, there was not much turnover to be had – not even for Peary. The

NORTH POLE ... COOKED, 1909
Ohio State University

WHAT'S THE DIFFERENCE ...?, 1909
Ohio State University

LA CONQUÈTE DU PÔLE NORD
The Battle for the North Pole
Universal History Archive

world was suddenly a different place and could thus simply observe how Cook went to pieces, partly as a result of Peary's campaign, partly because it turned out that he too had to some extent manipulated the account of another of his feats – the ascent of the mighty Mount McKinley in Alaska; and yet this man had plenty of achievements to point to, indubitable achievements like his collaboration with Amundsen in Antarctica, for example. The down trip was total for Cook, who ended up in prison because of alleged economic irregularities in connection with an oil adventure in Texas – the judge was a friend of Peary's family – and he never recovered his original stature. Peary, on the other hand, manoeuvred his way through and was able to maintain his reputation, even though posterity has denied him achievement after achievement. His incorrect map of Peary Land in North East Greenland probably cost the later explorers Mylius Erichsen, Høegh Hagen and Brønlund their lives.

The Cook versus Peary affair stands today as a demythologization of the heroic tales. The national interests behind their achievements were not strong enough; at most they could be brought into play as fodder for the self-perpetuating battles of the press. On the other hand the personal interests behind their achievements were so strong that they led them astray. ‡

PET

A COLDNESS BETWEEN THEM
29 September 1909. Illustration shows Arctic explorers Frederick A. Cook and Robert E. Peary on either side of a frozen figure.
Mary Evans / Library of Congress

To melt an iceberg

Tainted landscapes. The circumpolar region is currently the subject of tremendous artistic interest. As opposed to the Arctic landscape of Romanticism, the landscape today appears fragile and on the verge of disappearing. This affects the contemporary art. It is not a concrete discoloration of the landscape, rather a blow to the consciousness of the individual that has permanently deprived the Arctic of its virgin purity.

*I*t is an effective part of Thorkild Hansen's tale of Jens Munk's attempt to find and sail through the Northwest Passage for the Danish-Norwegian King Christian IV in 1619 that Munk did not know what awaited him[1] – it was "learning by doing", part of the very concept of 'discovery': To be where no one has been before. Even on the most carefully planned expeditions one must acknowledge that unpredictability is the real constant in the Arctic region. Munk had already travelled to the Russian city of Arkhangelsk on the Arctic Ocean at the beginning of the 17th century, and he imagined that his experience from the trip could be useful on the voyage through the Canadian archipelago: The route through the Northwest Passage had to be similar. But Munk's experience from the Barents Sea did not help him at all; he soon had to give up the dream of the Northwest Passage and instead just try to survive. He barely managed to return from the expedition along with two others, having been frozen in for the winter in Hudson Bay.

They slunk back home along the coast of Norway in the small ship *The Lamprey* after leaving the frigate *The Unicorn* along with the bodies of around 60 other crew members who had succumbed to scurvy and the cold. Munk's story is mentioned here because from the time of Munk, who in a Danish context represents a kind of beginning in the Arctic, far into the 20th century, expeditions in the Arctic were journeys into the unknown, and on these expeditions there were almost always disasters and substantial loss of life. Munk's example is thus the recurring story of the discovery and mapping of the Arctic. Like the Sirens in the Odyssey, the Arctic was beautiful, alluring and lethal, and it is this mixture of the joyful and the cruel that lies at the heart of the idea of the sublime that characterised the artwork that adopted the Arctic theme in the 19th century. A caricature in the satirical political magazine *Puck* at the end of the 19th century aptly describes this vast, white, barren landscape as "The World's Morgue".[2]

The British artist Darren Almond (born 1971), in his video piece *Arctic Pull* (2003), has thematised precisely this story of mankind's struggle to conquer deadly Arctic nature. One could call it a monument to the discovery and exploration of the polar region. The work shows a figure who fights his way through an endless snowstorm in total darkness, lit only by the infrared beams of the camera. The man is struggling forward, and we hear the amplified sound of the sledge runners being pulled over the ice. A monument to the will, or to "man's unceasing struggle to conquer his environment", as the construction of high-tech military bases in the Arctic is described in a U.S. propaganda film from 1961.[3] In the 1800s, the century of the Arctic's artistic breakthrough, several of the Romantic painters took the Arctic landscape as their subject, portraying its unparalleled grandeur and beauty as "the sublime dwelling-place of God, into which humans venture at their peril."[4]

Before Romanticism, the Arctic hardly played any role in the visual arts, and by the end of the 19th century it had virtually disappeared again as a subject.[5] There were several reasons for this, three of which

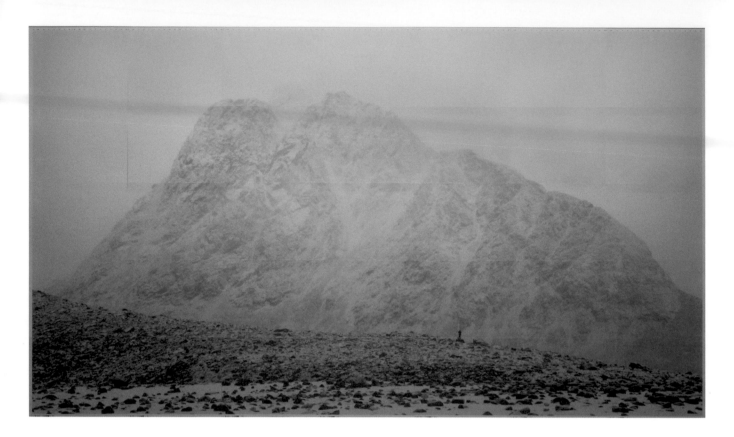

must be emphasised as particularly significant. First of all, one must point out that in the 19th century art moved further and further into what the philosopher and literary critic Walter Benjamin described as "the age of mechanical reproduction", and on expeditions photography replaced painting in the portrayal of the wilderness. Painting could not match photography as a witness to the truth. Next, we must remember the generally declining interest of the arts in portraying the outer world, as the focus shifted towards more specific investigations of art itself. Finally, one must understand the gradually more thorough surveying of the circumpolar region as a demystification of the landscape: Interest in the subject simply waned as it dawned on people that the North Pole, for example, was not a portal to a civilisation inside the earth; some of the magic simply disappeared. At the beginning of the

20th century, the Arctic was largely discovered and identified. It was assumed at the time that one of the two Americans Frederick Cook and Robert Peary reached the North Pole in either 1908 or 1909.[6] It later turned out that probably neither of them was there. But regardless of the exact extent of their undertakings, they still symbolised the demystification of the place in the collective consciousness – man had reached the highest, the furthest, the most inaccessible point.

The German artist John Bock (born 1965) has made a video piece, *Skipholt* (2005), in which, to exaggerate somewhat, he gives himself the role of a male polar hero. Bock appears in the work as Peary, Cook, Amundsen, Nansen and others, out to conquer the landscape and plant his victorious flag. Only Bock's polar hero is notable for his decidedly anti-masculine performance. There's some Freudian limpness

and thus impotence in Bock's figure. Perhaps it is an image of an ideal that has lost its validity. According to the German philosopher Hans Magnus Enzenberger (born 1929), the conquering hero is completely finished, and we must put in his place a new hero: a hero of retreat, who stands for withdrawal and surrender.[7] There is no other place on the planet where this seems more evident than in the Arctic.

THE ARCTIC REBORN

In recent decades, the Arctic landscape, as mentioned above, has resurfaced in art again, and to such a degree that it can easily compete with its original introduction. A triumphant return for the wild, untamed and icy landscape after more than a century of absence, perhaps. But the region's comeback is not necessarily the same as a return to Romantic ideals of the sublime in the eerie wasteland, because as suggested in the introduction, our view of the place has changed – and thus also the art that treats it. The landscape has been mapped and thoroughly photographed – and most important, we know today that it is extremely fragile and is crucial to our life on earth. Nature thus appears "no longer as something that God has created, but seems to be full of illogical and terrifying forces that man cannot master."[8] Nature's unpredictable forces and disasters, those already occurring and, not least, those *possible*, are an important part of today's media images, in which we are often told how our presence in the world could ironically end up being our downfall: "we now know there is no safe distance from which to view nature while enjoying a delicious *frisson* of horror."[9]

In the work *Icefall*, which was created for the exhibition at Louisiana, the Danish artist Jacob Kirkegaard (born 1975) plays with our imaginings and fears. In a large, monumental and almost dark room, we move around on a floor where sounds of ice melting, creaking and crackling come from various locations. Kirkegaard's precision in the placement of sounds gives space to the darkness we find ourselves in. We understand our position through the progress from one sound to another. The sounds range from the very slightest and fragile to the deep and resounding. The work challenges our perception and plays with our imagined world and the boundaries of both. Kirkegaard recorded the ice sounds with equipment that hears what our ears do not hear, and there is therefore no genuine realism to trace here. Almost like a geologist, Kirkegaard collects sounds and processes them digitally so that they become something other than what they were. The static, monochrome landscape comes alive, and the foundation beneath us shifts and shakes from time to time.

There is great agreement on modern mankind's interfering role in drastic climate changes, and environmental activists, movie stars and politicians take turns in sounding the alarm. In magnificent satellite images and time-lapse recordings, we see the ice resolutely retreating year after year. Fears that the landscape is changing drastically are great and seem inextricably linked with the unsurpassed beauty that prevails there. We fear the loss of the scenic more than the unscenic, and it must be said that often an understanding of the ethical comes through the aesthetic. One could also ask about "what happens

MARIELE NEUDECKER
There Is Always Something More Important (Iceberg), 2012
Fibreglass, pigment, plywood, 2 channel-video on two monitors, 207 x 65 x 380-440 cm
The Artist, Galerie Barbara Thumm, Berlin & Thomas Rehbein Galerie, Cologne

JACOB KIRKEGAARD
Field work for *Isfald*, 2013.
Icefall. Sound installation.
Louisiana Museum of Modern Art

to those places that are strange, unfamiliar and ugly? How will valuing based in aesthetic experience motivate care and respect towards environments with which we have no developed relationships?"[10] Our interest in the Arctic landscape is thus grounded in the aesthetic, and the great interest of contemporary art is also based on this relation.

The melting landscape has escalated the geopolitical interest in the Arctic, with the nations within the Arctic Circle trying to reach an agreement on who has rights to what at the bottom of the Arctic Ocean. The irony, of course, is that it is especially the overconsumption of fossil fuels that has created the drastic climate changes that now facilitate access to even more of this forbidden candy. Mankind's relation to the Arctic landscape thus seems almost incestuous, connected as it is with uncontrollable urges and boundless shame. While the Arctic landscape once appeared infinite and unknown, today we know almost everything about it and what we are doing with it. It is the movement from the unknown to the known that is interesting in this context because the horror that in Romanticism was largely associated with lack of knowledge exists today in quite a new form: as a horror based on understanding and in-depth knowledge. The Arctic landscape remains terrifying, because it is still endlessly beautiful and glorious and because we also know that it is disappearing or at least drastically changing – and that we are the cause. The work *There Is Always Something More Important* (2013) by the German artist Mariele Neudecker (born 1965) depicts a slice of an iceberg as though Neudecker has cut herself

a piece of birthday cake from the Arctic ice, and also includes two small flat screens with footage of icebergs. The motif is iconographically connected to the Romantic tradition of the wild and pristine, and then it has been processed, influenced by human intervention and accompanied by the statement that there is always something that is more important. The aesthetic of the sublime in contemporary art is closely and ironically connected to mankind's power over nature, a power that is so pronounced that parts of aesthetic theory no longer endorse a belief that *nature* is even a valid concept.[11] Not only have we defeated it; we can now no longer understand it as actually existing. In the photographic piece *Greenland* (2010) by the German artist Wolfgang Tillmans (born 1968), we see a snowy Arctic landscape from the photographer's position in an aeroplane. We are far removed from the landscape and moving away; the photo seems nevertheless to contain a yearning for lost innocence. The aircraft that enables our viewing perspective is probably the ultimate symbol of technological alienation from nature, in this case the Greenland ice sheet, in the sense that the plane enables us completely to avoid the unpleasantness and unpredictability that a journey across this landscape could entail. Almond's monumental *Arctic Pull* should be adduced here in comparison. Tillmans' image is sublime, but not because man proves to be inferior to God or nature as in Romanticism. On the contrary, the sublime resides in the photographer's sovereign position in the aeroplane, and it is closely related to man's ability to "triumph over nature with the aids of modern technology."[12]

WOLFGANG TILLMANS
Grønland, 2010
Greenland
Inkjet print on paper, 240 x 158 cm
The Artist and Andrea Rosen Gallery,
New York

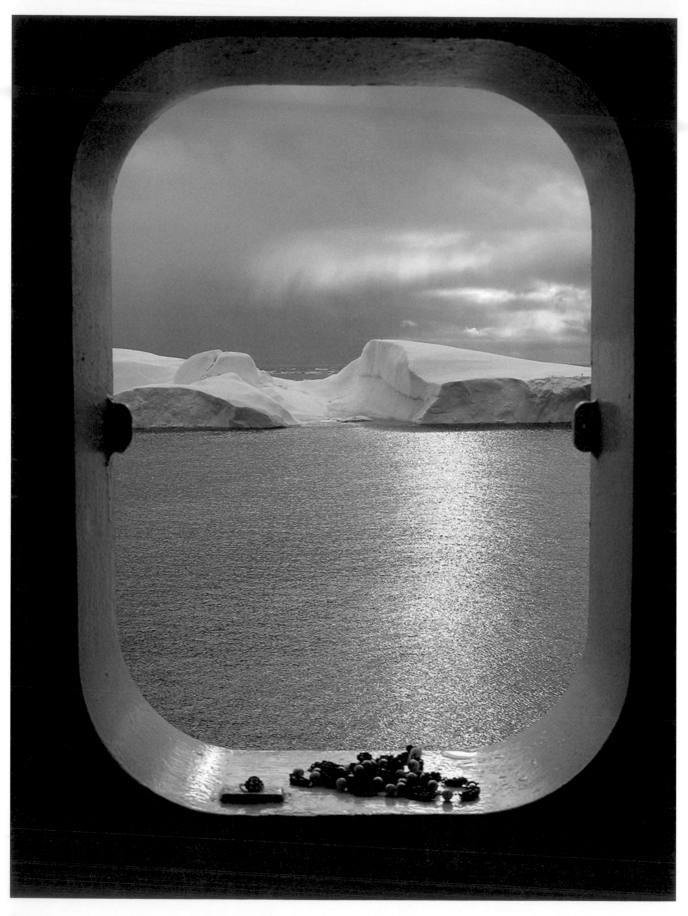

LANDSCAPE

A degree of nostalgia seems to have become embedded in our view when we direct it farthest to the North. A sense of loss and shame accompanies us, to an even greater extent than for other types of landscape, such as primeval forest and wetlands. The inevitable loss of energy in matter, the principle of entropy, is most clearly exemplified in a landscape of snow and ice. But is there anything at all there to direct our gaze towards? What do we see that is not simply our own dream or nightmare? Is that not precisely one of the points of Kirkegaard's *Icefall*? Perhaps the Arctic landscape, farthest to the north, with its absence of human emblems and references, is the ideal mirror. Perhaps what we are experiencing is "a polar scene of ice and snow as revealing something fundamental (and no doubt grim) about how things really, or ultimately, are: something concealed from us in more familiar, temperate, farmed countryside."[13]

The French artist Sophie Calle (b. 1953) highlights the distinctively changeable Arctic landscape in her piece *North Pole* (2009). The text describes how Calle, on an artistic expedition to the Arctic, held a small memorial service for her late mother. She buried some of her mother's jewellery along with a picture of her and wrote, in conclusion: "I wonder if her glacier will advance or retreat, if the climate changes will carry her

to the sea to be taken north by the West Greenland current, or retreat up the valley towards the ice cap, or if she will stay on the beach as a marker in time where the glacier was in the Holocene period."[14] Sophie Calle's work is not about climate change, any more than it is about the North Pole, but it is a fine illustration of the awareness that exists today – both in art and more generally of the changes in the Arctic landscape. Climate change is a prop for Calle's distinctive exhibitionism, and her work is characteristic of the contemporary art Louisiana has chosen to focus on, in that it does not engage in a debate about what is good or bad about these changes in climate. There is thus no finger pointing at Doomsday now, no "save the polar bears" campaign. Contemporary art's fascination with the well-known and well-documented climate catastrophe is in itself just as distanced as the Romantic fascination with the unknown, sublime landscape. One could see it as an expression of decadence – artists who play on while the ship is sinking – but it should rather be seen as an awareness brought about by a concern that is brought into art, which creates images more often than actual solutions. Others may choose to act on these images.

The Arctic landscape in art is first of all a desolate, icy landscape. This is where artists' primary interest lies, both in Romanticism and again today: one of the last "unmanufactured"[15] places – even if we may no longer think this is a valid designation. The Arctic has also largely – if you will excuse the expression – been stripped of scale, and those who visit the region may be exposed to a variety of sensory tricks played by the eyes in conjunction with the

landscape: mirages, whiteout, mock suns – all phenomena that enhance the otherworldly tone and present interesting issues that preoccupy artists. It is a place that confirms the notion of the constructed in our way of taking in the world, because the well-known regularities are so obviously out of play here. The piece *Mirage* (2012) by Marcelo Moscheta (born 1976), is a photograph of a huge, snowy mountain with an almost microscopic human form that allows us to understand the space and dimensions in the image. Moscheta has divided the work up into thirty-six aluminium plates that together create this great motif – but it must be assembled, constructed, in order for us to understand it, and then it can be taken apart again.

DARREN ALMOND:
ARCTIC PLATE. 1-15

Darren Almond's fifteen photographs in *Arctic Plate. 1-15* depict snow and ice formations in the Arctic desert. Almond "has made the diverse effects of light on the polar ice a theme in itself."[16] *Arctic Plate. 1*, for example, shows an inorganic accumulation of snow in a mound that makes one think of piles of sand and gravel created by the brutal operations of bulldozers around gravel pits and construction sites. Theodor W. Adorno (1903-69) makes us aware that "the parts of nature that are not subject to human care, not touched by human hands, such as alpine moraines and rock cliffs, look exactly like the industrial waste heaps that the socially recognised aesthetic need for nature is fleeing".[17] Almond's photographs depict just such an aspect of nature. The fifteen photographs are formally quite similar and differ from one another primarily in their various

CHARLES STANKIEVECH
LOVELAND, 2011
HD video installation
Installation view at MACM

monochrome tones, which are the first thing one notices when one sees them together. This is because of the camera's long exposures and increased sensitivity to changing light conditions. The tones from one photograph to another shift from greyish to greenish, from almost purple to very blue, and finally to completely white. Most of the photographs have no real horizon; instead it seems that the almost muddy skies wash down over the snow- and ice-covered expanses, so the gaze is not really allowed to rest in its pursuit of a constructed extremity. *Arctic Plate. 1-15* shows non-landscapes and non-places. We have no sense of scale in the photographs, and it is therefore impossible to fully grasp what one sees. A sense of space is "missing" in many of the images, which thus have a flatness and inaccessibility that are not rare in the Arctic ice landscape. In the Scott Polar Research Institute book the *Illustrated Glossary of Snow and Ice*, the phenomenon of whiteout, for example, is described as follows: "A condition in which daylight is diffused by multiple reflections between a snow surface and an overcast sky. Contrasts vanish and the observer is unable to distinguish the horizon or any snow surface feature."[18] Almond's photographs seem themselves almost like a lexicon in which one can look something up, a glossary in which the sparse light's play on the monotony of snow and ice is depicted. Almond's photographs present a kind of conceptual whiteout in which we as viewers are deprived of the basic reference points we have learned are part of a landscape theme. We are in this sense outside the realm of landscape. The photographs are desolate and barren, and they shine mainly through their otherworldly qualities

reminiscent of both moon landings and the colour photographs that the *Viking 1* spacecraft took on the planet Mars in 1976. There are no references we can cling to firmly. The human emblem, which in Romantic images reminds us that the picture's meaning lies in its reference and thus its interpretation,[19] is absent from Darren Almond's work, which in a sense can be said to zoom in on the diffuse horizons that often characterise Caspar David Friedrich's paintings – into nothingness: "Almond's polar photographs too seem to mark a journey beyond the natural, beyond non-fiction. With human reference lost, here, time becomes a function of the mysterious phase changes of water. It's all we see: black sea-flow, grey vapour, white pack ice. H_2O: the only chemical compound on Earth found simultaneously as solid, liquid and gas."[20]

To the formal characteristics of Almond's series a further element should be added: the titles. Almond call his photographs *Arctic Plate. 1-15*. Superficially, this appears to be a quite objective designation for the obvious: photographs from the Arctic. But the word "plate" seems to add to or subtract from the photos an essential quality: time. Or rather, we must define the relationship between the title and photographs as anachronistic: the word "plate" refers to a photographic technique that belongs to another era, a time when photography was performed with glass plates that were treated with chemicals and salts. The first photographs of the Arctic landscape were taken with this technique, and the word "plate" seems to refer to the time when the first photographic images of the Arctic appeared. We thus get an idea of a historically charged theme or subject field, as though

what we see is not the place, but the motif, which is quite a significant distinction. The photographs seem marked by time; they represent a type of sequence, as though the motif slowly disintegrates and disappears. In general, when we look at Almond's photographs, it is difficult not to feel that a motif is disappearing from our visual culture. It is not an eschatological proclamation; rather a kind of melancholy that is again reinforced by the word "plate" in an age when everyone has a digital camera. The landscape's fragility is reflected in Darren Almond's laborious and old-fashioned photographic method with long exposures. It appears to be a mirage, a dream vision. From photo to photo, we see the light, interacting with the snow and ice, change its nature as a kind of timekeeper. Almond is obsessed with clocks. We do not know where we are or what time it is, and Almond has apparently made a point of anchoring his work in a kind of continuous always: "frozen water solidifies from light snow into a hard crust over the course of years, decades, millennia."[21] Look at *Arctic Plate. 1* and *Arctic Plate. 15*, which is the last work in the series, if we attribute any importance to the numerical order. It is clearly the most washed out, like a monochrome canvas, and in the context of the other fourteen, it looks like a ruin, almost in the Romantic sense.

"Nature here is both created and perceived by Almond's lens – at once, both imagined and actual."[22]

GUIDO VAN DER WERVE: NUMMER ACHT, EVERYTHING IS GOING TO BE ALRIGHT

If one painting could be designated as the very image of the Arctic wilderness, it would probably be Caspar David Friedrich's *Das Eismeer* (1823/24), in which a wrecked ship called *Hope* is being engulfed by heavy slabs of ice. Now, almost two centuries later, the ship and the Arctic Ocean have again become an artistic motif. This time in a video piece by the Dutch artist Guido van der Werve (1977) entitled *Number Acht, Everything is going to be alright* (Number Eight, Everything . . . , 2007). The number eight indicates that the work is the eighth in a consecutive series of video pieces by van der Werve, who is also a trained classical pianist. The video series is a sequence of symphonies. Van der Werve has described the goal of his work as, among other things, an attempt to create expressions that have just as direct an effect on the viewer as a piece of music – a type of synaesthetic paradigm shift that is akin to Romantic thought.[23] *Number Acht, Everything is going to be alright* is a ten-minute video in which the artist moves across a frozen sea with a huge icebreaker at his heels. The audio one hears is the icebreaker's slow but constant chuffing as it ploughs through the frozen sea. The work is very simple and strong in its expression. An obvious reference one must of course mention is the image of the lone Chinese protester in front of the row of military tanks in Tiananmen Square in Beijing in 1989. Van der Werve's image involves a similar clash – the small, powerless person set against a powerful, gigantic machine. The image from Tiananmen Square is a photograph, and van der Werve's is a video; but the latter seems in many ways like a still image as well, because, despite its being in constant motion, it has a somewhat flat dramatic trajectory: the piece ends in exactly the same way as it starts,

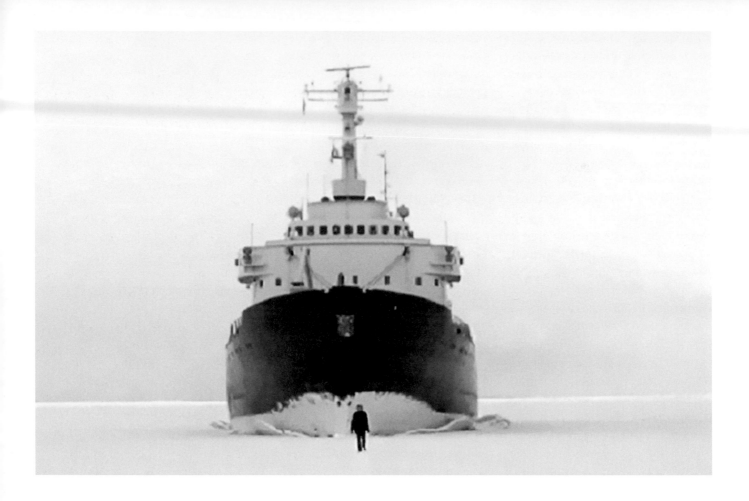

GUIDO VAN DER WERVE
*Nummer Acht, Everything is going
to be alright*, 2007.
16 mm to HD, 10 mins, 10 secs
The Artist and Luhring Augustine,
New York

with van der Werve in front of the icebreaker – he will not be overtaken, but neither will he get away. The piece toys with the idea of the potential disaster into which the image could develop: "The lone wanderer lost in a meditative gaze, is a Romantic emblem."[24] We know the man in van der Werve's work – the figure, that is, which is especially prominent in Caspar David Friedrich's work. But van der Werve's man differs of course from Friedrich's, who is always located on the edge of the wilderness, in that van der Werve finds himself in the eye of the storm, so to speak, on a never-ending odyssey towards the foreground of the image, which, however, is constantly moving further away. We thus have three points in the piece that move in synchrony at the same pace: the viewer/camera, van der Werve and the icebreaker.

How many ships went down, froze or were crushed in an attempt to reach the North Pole or find the Northwest Passage? Again we recall Friedrich's *Hope*. The icebreaker, "a maritime freak",[25] is highly advanced. It does not cut through the ice but glides up on to it and uses its weight to break through the ice from above: "Altogether an extremely complicated and expensive piece of equipment."[26] A stellar example of man's triumph over nature. It is a vessel like this that puts previously very inaccessible regions and landscapes within reach. There is no place we do not go today, and it is hard to avoid seeing van der Werve's work as a flight/chase. A wistful, Romantic image of someone who

dreams of being at one with nature but who is relentlessly hunted by technology and modernity. Here the absolute opposite of the Tiananmen Square reference must be brought into play. For another reference that forces itself upon us, although it is hardly intentional, is Michael Palin's intro at the beginning of each episode of *Monty Python's Flying Circus*, in which, dressed up as a tattered hermit, he fights his way towards the camera, which constantly zooms further out, until he can finally say the famous and canonised "it's". For parody is also an active part of van der Werve's otherwise grandiose work. It is both a humorous and a terrifying chase scene, a hubris-laden picture of man's conflicted relation to his own misdeeds, man as a part of nature but also a complete stranger to it. The title of the work adds to the comic aspect that underlies the entire film: *Everything is going to be alright*. On the face of it, the title gives assurance that

nothing will happen to the protagonist, while the statement is so limp and general that it can be seen as a special attitude towards things – a *laissez-faire* attitude. The statement "Everything is going to be alright" in this sense presents the central motif of hubris in the work. Here one could again highlight Mariele Neudecker's finely constructed iceberg in *There Is Always Something More Important*, a good interlocutor for van der Werve's statement.

"Everything is going to be alright," says the first one, to which the other replies, "There is always something more important." NOT, we might add.

THE FRAGILITY OF THE SUBJECT

Contemporary art's interest in the Arctic landscape is directly connected to a universal human concern about the climate disasters that will eventually hit us in our respective homes, but perhaps more impor-

tantly, also to a concern about losing a last sanctuary on earth, a place that is so completely *not* us and our world, and we wish it would stay that way: A refuge at the top of the globe. The artists meet the landscape with a melancholy that is almost museological, geological, zoological, anthropological and climatological. They collect, register and note in their fieldwork with a great awareness of the fragility of the subject– and they go their own separate ways. Caspar David Friedrich depicts human civilisation as destructed, as ruin, in the confrontation with the Arctic winter. In contemporary art, the landscape itself has become the ruin. Not because we know it will disappear, but because we talk about its probable disappearance, it is in a sense already gone. ✲

Mathias Ussing Seeberg (b. 1981), M.A. in art history from the University of Copenhagen, formerly engaged as a curator at the Arken Museum of Art. Curator of the exhibition ARCTIC with Louisiana's director Poul Erik Tøjner.

1 Thorkild Hansen, *Jens Munk* (Gyldendal: Denmark, 1965). 2 *Puck*, 20 August 1884. 3 US Army, *The Story of Camp Century – The City Under Ice* (film, 1961). 4 Diana Donald, "The Arctic Fantasies of Edwin Landseer and Briton Riviere: Polar Bears, Wilderness and Notions of the Sublime", accessed 9 June 2013 at http://www.tate.org.uk/art/research-publications/the-sublime/diana-donald-the-Arctic-fantasies-of-edwin-landseer-and-briton-riviere-polar-bears-r1136829. 5 There are of course a few exceptions, such as the Canadian Group of Seven, who painted voluminous Arctic landscapes in the 1920s and 1930s. There was also Max Ernst's little cosmogony, *Der Nordpol*, from 1922. 6 In a short silent film, one can see Frederick Cook arrive in Copenhagen by ship in 1909 to a cheering crowd and being received by King Christian X as the first man to reach the North Pole. 7 Hans Magnus Enzensberger, "Tilbagetogets helte", *Information*, 13 March 1998. 8 Bo Nilsson, Foreword to *...om det su-* blima... (Rooseum: Sweden, 1999), pp. 7-8. 9 Samantha Clark, "Contemporary Art and Environmental Aesthetics", *Environmental Values* 19 (White Horse Press, 2010). 10 Emily Brady, "Aesthetics in Practice: Valuing the Natural World", *Environmental Values* 15 (White Horse Press, 2006). 11 Fredric Jameson, *Postmodernism, or the Cultural Logic of Late Capitalism* (Duke University Press: Durham, NC, 1991), p. xi. 12 Bo Nilsson, Foreword to *... om det sublima...* , p. 12. 13 Ronald Hepburn, "Landscape and the Metaphysical Imagination", in *The Aesthetics of Natural Environments*, ed. Allen Carlson and Arnold Berleant (Broadview Press: Canada, 2004), p. 127. 14 Sophie Calle, *North Pole* (2009). 15 Theodor W. Adorno, "Det naturskønne", in *Æstetiske Teorier*, ed. Jørgen Dehs (Odense Universitetsforlag: Denmark, 1998), p. 51. 16 Monica Faber, "Infinite Ice – On Photographers' Perception of the Alps and the Arctic since 1863" in *Infinite Ice, The Arctic and the Alps from 1860 to the Present*, ed. Monica Faber (Hatje Cantz: Germany, 2008), p. 17. 17 Theodor W. Adorno, "Det naturskønne", pp. 58-59. 18 Terence Armstrong, Brian Roberts, and Charles Swithinbank, *Illustrated Glossary of Snow and Ice* (Scott Polar Research Institute: UK, 1969), p. 40. 19 Marie-Louise Svane, *Formationer i europæisk romantik* (Museum Tusculanums Forlag: Denmark, 2003), p. 153. 20 Brad Barnes, "White Fever", in *Darren Almond, 11 miles ... from Safety* (White Cube: London, 2003), p. 3. 21 Monica Faber, "Darren Almond – Arctic Ice, Arctic Time", in *Infinite Ice, The Arctic and the Alps from 1860 to the Present*, ed. Monica Faber (Hatje Cantz: Germany, 2008), p. 94. 22 Brad Barnes, "White Fever", p. 6. 23 Marie-Louise Svane, *Formationer i europæisk romantik*, p. 63. 24 Marie-Louise Svane, *Formationer i europæisk romantik*, p. 80. 25 David Fairhall, *Cold Front: Conflict Ahead in Arctic Waters* (Counterpoint: USA, 2010), p. 107. 26 David Fairhall, *Cold Front: Conflict Ahead in Arctic Waters*, p. 111.

The resolute explorer

The story of Salomon Andrée's balloon expedition is the most tragic and pointless of all. Everything went wrong, just as the sceptical and critical opposition had predicted. And they all died – Andrée, Knut Fraenkel and Nils Strindberg, three relatively young men aged respectively 43, 27 and 25, the last of them recently engaged.

Andrée's balloon voyage is a strange story, one of whose themes is the honourable duelling and masculine sportsmanship in the culture of the polar expeditions. But first and foremost, it is full of contradictions down to the last detail. In Andrée's time it was thought that balloon voyaging was on the side of the future. There were great expectations of it as the technology that could raise mankind above earthly tribulations – and not only metaphorically, although it is hardly to be doubted that the whole symbolism of drifting high across the earth with nature at your back contributed to the exalted prospects that prompted balloon voyaging.

Andrée was no sucker for romantic notions about either polar exploration or ballooning; he was trained in the technical sciences and was a hard-headed rationalist. He believed in progress and indus-

try, in reason and in the future. But above all he was a fervent enthusiast and indomitable optimist. His persuasive powers were great – both Alfred Nobel and the Swedish King contributed financially to the Swedish venture, which was to fuse science with passion. The critics had said that no balloon would be able to maintain its buoyancy over such a long period in the climatic conditions of the Arctic – it would be weighed down by snow, ice and water. Andrée took a different view, although when he finally took off from Svalbard in the second attempt he was himself secretly convinced that it would never succeed. But quite heart-rendingly, he had become a prisoner of his own role: To give up in the face of a public that had listened to his enthusiasm was not an option, although Nansen himself had tried to advise him against the enterprise. "Suicide in a balloon" remains the gruesome evaluation on paper of this expedition: a counterpart to Nansen's drifting with the ice to the north, but now with the wind. Posterity has discussed what actually meant most to Andrée: reaching the North Pole or proving the potential of a particular technology – ballooning – and most observers incline to the latter. Andrée was a scientist – he was not the fantast that the story seems to imply, now that we know how it all ended. All the same, there is an odd irony in the fact that Andrée, who was first

and foremost obsessed with any kind of control, including self-control (which is why he cared nothing for concepts like love) took up ballooning, which at least in some ways was at the mercy of forces outside the captain's competences. So it was not so strange that the scientific temper and the whole spirit of the expedition quickly had to yield to the basic struggle for survival.

On 11 July 1897 the wind was favourable, and Andrée and his people were ready to start. The balloon rose to the sky, then after a few minutes – as an eerie omen – almost fell into the sea, buffeted by gusts of wind from Svalbard's surrounding heights. Then the balloon drifted off as it was supposed to – with the highly crucial exception that during the initial plunge it had lost the lines with which it could be piloted – insofar as it could be piloted at all. Now they were totally at the mercy of nature's own whims and drifted as the wind blew. Which it did, and from a variety of directions. They hovered motionless in the 'eye' of the wind, or they drifted towards the west, then suddenly they drifted back towards the east, and never progressed much towards the north. They also got into trouble – just as the sceptics had said – losing buoyancy. They made the basket lighter and lighter by jettisoning ballast, but the balloon itself grew heavier and heavier, enveloped in condensation as it was. They bumped along, frequently touching

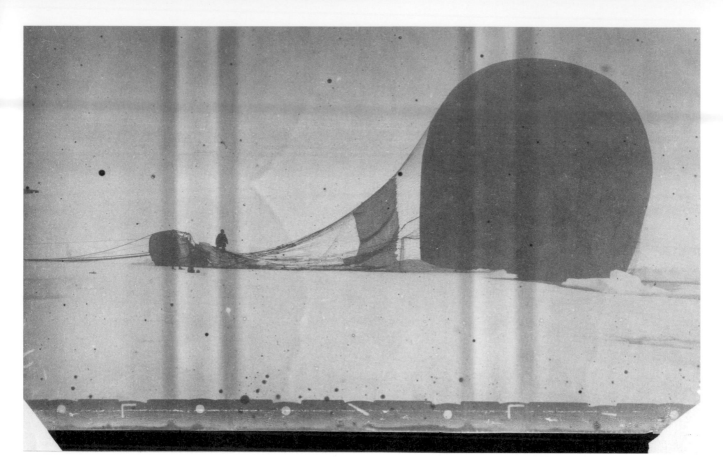

the ground (or rather the ice), and finally it was over. There lay the balloon like a huge wounded bird, a heavy, dark monument to shattered hopes and an impossible lightness. The photographs have their own aura of resignation amidst all their objectivity. And that was that.

From there things deteriorated in every way. They wanted to go back, on foot, with sledges and a small boat, over thousands of icy obstacles in the worst conceivable weather, with dense fog and increasing cold. At first they tried to reach Franz Joseph Land, then they changed course, because it turned out that each time they had covered a good distance with great difficulty, the ice had drifted the opposite way. So they were going nowhere, and in the end they just had to drift with the ice – as the balloon had done with the wind – in the simple hope of striking some land. And in the end they did, on a tiny island east of Svalbard, almost covered by a glacier, but otherwise just rocks. They pitched a tent, but never managed to build a proper windbreak. Strindberg was the first to die, then Fraenkel and Andrée.

We know all this, or almost all of it, because thirty years later the three bodies were found as well as what they had left behind, including a number of matchless photographs. Five rolls of film were found, each with 48 pictures, and 93 of them were saved and are now being shown for the first time in their entirety in connection with the Louisiana exhibition. Salomon Andrée's air voyage in his balloon named The Eagle thus becomes eerily present in all its grandiose failure. In Niels Strindberg's pocket, two tickets were found which he had kept after a visit to the Stockholm Exhibition with his fiancée, as well as a small medallion. It is heart-rending, everything just went wrong, and we can see it in black and white. Come see for yourself ... ‡

PET

THE EAGLE HAS LANDED,
Andrée's balloon *Örnen*, The Eagle,
July 14, 1897

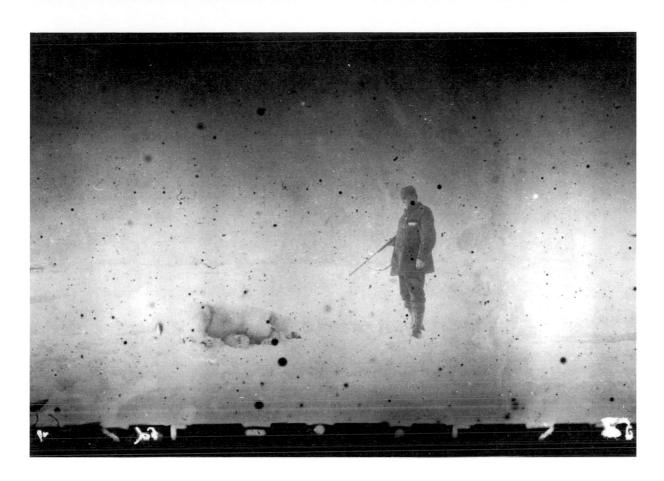

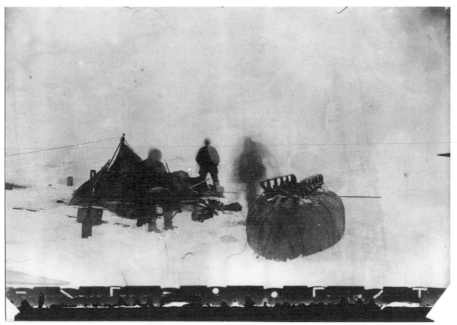

HUNTING
S.A. Andrée with slayed icebear, 1897

CAMP
All crew members by a stock, 1897

Frozen
Light

Expedition photos. The polar explorers knew how to mythologize themselves properly in diaries, travel notes and accounts. The expedition photographs, on the other hand, exhibit a strange aura of doom.

I hate travelling and explorers. A great and famous first line from Claude Levi-Strauss's *Tristes Tropiques* because, for the reader – and who knows, maybe even for the author as well – it is such a provocative untruth: we *love* explorers. When we're tired of every other kind of reading expedition we'll trudge along in the footsteps of the great explorers; even if we no longer have the stamina to read about them, we'll settle for pictures of them.

And what about Albert Camus's claim, in the opening line of his essay *The Minotaur or the Halt at Oran*, that "There are no more deserts, there are no more islands"? How can that be true, even at some metaphorical level? OK, the Maldives might sink beneath the waves in the not-too-distant future but there are still plenty of islands left – I live on one – and there are loads of deserts. The danger, as I understand it, is that if we're not careful we'll lose some islands and there will be nothing *but* deserts.

It's the ice that's endangered, receding and melting by the day, making polar exploration a thing of the past when it's *already* a thing of the past in that the only thing left to do is to do again the things – man-hauling across some much-traversed expanse – that were done so early in the twentieth century it looks like the nineteenth. In that distant past it was the explorers who were at risk from the ice and everything associated with it, not the ice that was at risk from man and the man-made. So maybe a compound amendment of Camus and Levi-Strauss is in order: "I hate the way that there are no more explorers."

Photographs of these old explorers, even ones who made it back, who lived to tell their tales to packed crowds at the Royal Geographical Society, always have a sense of doom brooding over them like a dark sky, as if they – the photographs – weren't expected to be carried back by the men who are in them or took them, but by later expeditions searching for traces of the earlier ones. Sometimes search parties would find the bodies as well as the photographs, journals and letters. Sometimes there'd only be the words and pictures, seemingly written and taken without any shadow of doubt – these were the days before 'unreliability' became a key component simultaneously underpinning and undermining the assumptions of modernity – that they would one day be found and seen. How comforting it must have been, shutting one's eyes for the last time, secure in that faith. The island castaway stuffing a message in a bottle hopes to be rescued; the polar explorer scribbling in his diary knows that he will be remembered. The incentive to self-mythologize, to cover up one's blunders, deny allegations of incompetence – "If Scott fails to get to the Pole he jolly well deserves it," griped fellow expedition member Titus Oates – and apply what will hopefully prove a lasting gloss to one's posthumous reputation is, in such circumstances, considerable. "We are showing that Englishmen can still die with a bold spirit, fighting it out to the end," wrote Scott of the Antarctic (as he "prepared his exit from the stage," notes Roland Huntford in a damning re-assessment almost seventy years later).

Scott's prose is frequently and uncharacteristically grandiose. In an essay of genius, *An Expedition to the Pole*, Annie Dillard observes that the default style of the polar explorers, even in the intimate setting of their journals, tends toward "a fine reserve." Were they selected for the task of exploration, she asks, on the basis of "the empty and solemn splendour of their prose"? Going

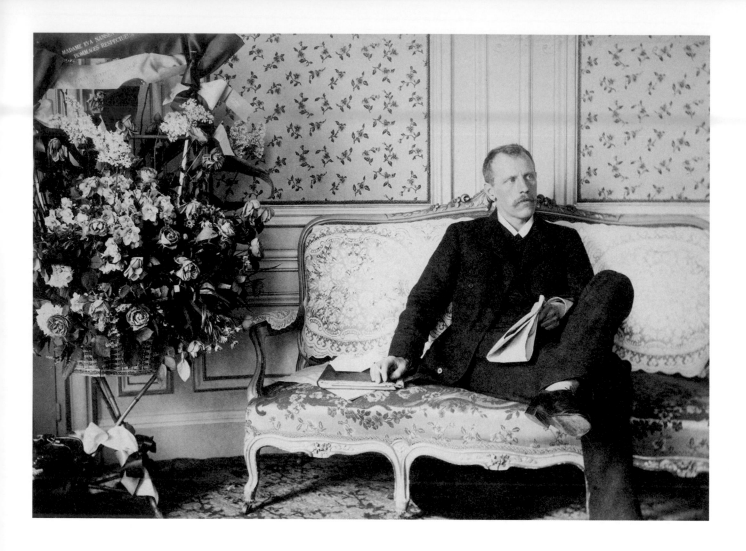

FRIDTJOF NANSEN
Nansen in a parisian hotel room during a lecture tour in 1897 after the North Pole Expedition. The bouquet is for Nansen's wife Eva who played a koncert in town.
Nasjonalbiblioteket, Oslo

further – Dillard is nothing if not an intrepid explorer of barmy ideas – she wonders "if some eminent Victorians, examining their own prose styles, realized, perhaps dismayed, that from the look of it, they would have to go in for polar exploration." The picture of Nansen seated in his parlour would seem to have caught exactly this determining moment of awakened self-knowledge. Dillard follows her own question by immediately quoting Andrée, as he con-

fides in his diary "with almost his dying breath, 'Our provisions must soon and richly be supplemented, if we are to have any prospect of being able to hold on for a time.'"

I could easily – and perhaps should – learn more about Nansen and Andrée. The pictures, after all, are of famous expeditions, about which a certain amount is known. Normally photographs encourage you to do precisely this, to enable access to lengthier and more com-

prehensive mental captions. These extraordinary images have the opposite effect.

Rather than being part of a larger explanatory record I prefer to think of them as furnishing the sole evidence of expeditions about which nothing else is known. Like this they provide "a kind of truth" that might be "the enemy of the merely factual. Ecstatic truth, I call it." The words are Werner Herzog's, from an explanation of why his documentaries rely on touches of fabrication and invention, thereby breaching the assumed obligations of the form. Isn't *that* what the Andrée pictures most vividly resemble? A stash of stills from a lost Herzog film in which the documentary sublime and the painstakingly fictive are impossible to distinguish: a sci-fi movie stranded in the icy wastes of the past, or a historical drama set several days after tomorrow?

The soundtrack to this tragically vanished or un-made epic is rumoured – by me – to be by the Australian trio The Necks. Taken from a sequence from their hour-long track *Silverwater*, the main theme of the movie sounds like the last transmission from the crew of a space station: doomed when first sent, dead by the time received, but still faintly bleeping its way through the rest of eternity. That's what I *hear* in these pictures, made at a time when the polar night must have seemed as infinite, distant and dark as space itself.

As with Robert Capa's D-Day photographs, they're enhanced by damage and imperfections which seem immanent rather than intrusive, emanating from rather than imposed upon. The harm to the Capas was actually done back in London, in the safety of the lab, but they seem imprinted and drenched with the danger and salt-water of Omaha Beach. I'm unclear as to when the flurries and sleets of blurs and blobs began to afflict the polar pictures. In the process of being made or in the course of their long afterlife? Has time played an active part in the emergence of their distinctive look and flavour – as happens, according to Ryszard Kapuscinski, in the production of cognac – or has it merely stored and preserved what was damaged from the outset? Either way, compared with Frank Hurley's immaculately magnificent photographs of Shackleton and the *Endurance*, these images are stoically flawed – frostbitten – by the experiences depicted. Some consist of nothing *but* the flaws, as if life, at a certain point, shrank to an agonized breathing that eventually became indistinguishable from the howling wind. A swirling diminution of the visible slowly gave way to an all-engulfing emptiness – and we can *see* this happening.

Some, on the other hand, could almost pass as generic ancestors of the holiday snap. Once the destination – the ice – is reached, however, a vital difference emerges. Snaps are taken by the holidaymakers themselves whereas the best of these *appear* not to have been taken by members of the expeditions. They seem – and this essay, as will by now be clear, is a faithful account of a viewer's responses to certain pictures, not an explanation of the circumstances of their production – to have been made without human intervention, as if the place itself somehow achieved the means to record and preserve the bizarre activities of the people visiting it. (In a few instances they seem almost to have been made without the benefit of a camera!). As a result a place which, in the normal course of things, had nothing to look at – or with – for half the year stood briefly revealed to itself in a new and strange, that is to say *human*, light. Maybe that's why, instead of just looking at the pictures and marvelling at the ingenuity and resilience depicted, we *inhabit* them. On occasions, as when animals are being killed – a necessary and eminently reasonable task from the point of view of the explorers – the pictures have about them the qualities of evidence and potential indictment.

More usually the activities recorded seem absurd or ludicrous. At times this barely sentient landscape, entirely reliant on its blemished sense of sight, becomes a species of silent anthropology, struggling to understand what is unfolding incomprehensibly in its midst. Essentially this boils down to the simple question: why on earth have they come here? This – to change terrain and climate dramatically – is how the watching Indians, hidden behind the jungle screen which was like a botanical extension of their being, viewed Columbus and the other invaders from Europe. The so-called new world, from their point of view, was actually the old world, or more accurately, the *only* world. Especially since notions of old and new depend on a conception of time which, prior to the arrival of Europeans, did not exist.

It's a different kettle of fish up here in the Arctic where explorers encountered a kind of massively distended version of the time with which they were familiar and on which their plans depended. Measured round the belly of the planet, the illuminated part of a day lasts about twelve hours. Here it lasts six

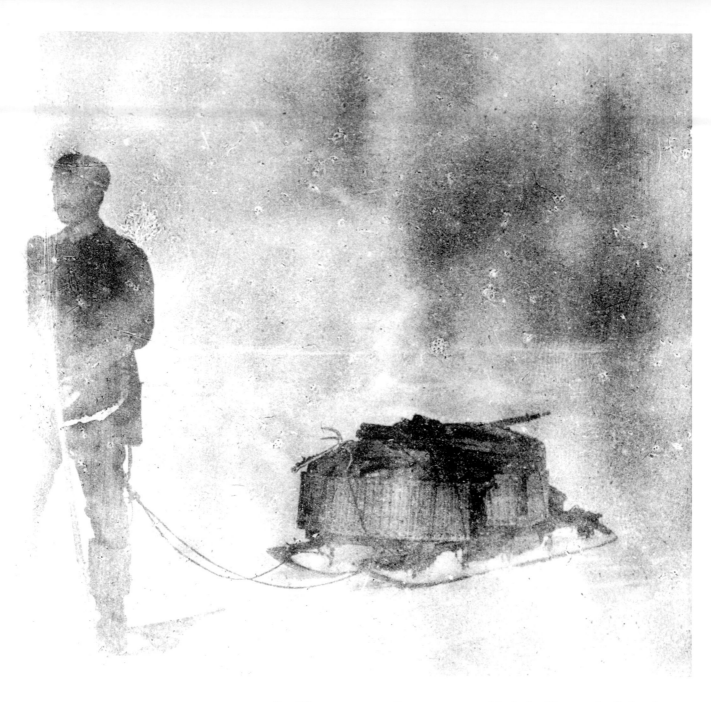

NILS STRINDBERG
Strindberg with sledge, 1897
Developed, un-retouched photo by S.A.
Andrée from the lost Andrée expedition

months. Time passes, as they say, at a glacial pace. Photographs are often thought to freeze time. Here it's *already* frozen and in these pictures it's as if we see frozen time in the process of thawing. Frozen and thawing in the same image – which is not so different, when you think about it, to dead and breathing. By these terms the most severely distressed pictures are less records of the dying of the human light than a kind of self-portrait of a landscape in recovery, one by which an alien presence is gradually enveloped – but never quite forgotten. ‡

Geoff Dyer (b. 1958), English author and cultural critic, has published four novels, a succession of essay collections and most recently the book *Zona*, which is about Andrei Tarkovsky's film *Stalker*.

TRIVIA DISTANT EARLY WARNING LINE

It must be regarded as a coincidence – although a telling one – that the shortest route between the world's two old superpowers the USA and Russia goes over the top of the world. In the commercial aviation industry the Arctic has long been known as the Polar Short Cut, and the shortest route was of great strategic importance during the Cold War (from about 1946-47 until 1989-90), when Russia was part of the Soviet Union. The name *Cold War* could be taken to refer to the huge strategic importance of the Arctic, but in reality it is a metaphor for the absence of battles in the war. The nations prepared for war – nuclear war in fact –, stockpiled weapons and uttered rhetorical threats. But the true, direct confrontation never came, although it came close several times; the war was cold because it never really heated up. The USA built a radar system across the circumpolar region so they could detect attacks by the enemy in time to respond – this was called the Distant Early Warning Line or simply the DEW Line. From Alaska through the Canadian archipelago and across Greenland, military personnel sat in high-technology bases in the midst of icy-cold, totally desolate wastes, waiting for messages about the worst conceivable scenario. If this came, they knew exactly which receivers to lift.

DEW LINE
Telephones from radar station in Greenland

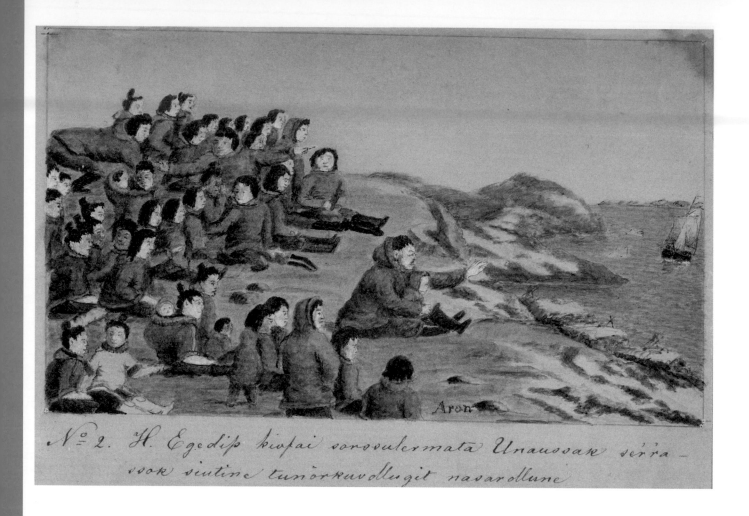

No 2. H. Egedib kiofai sorosvutermata Unaussar serra-
svor siutine tunorkuvollugit navarollune

TRIVIA ARON FROM KANGEQ

One of the richest sources for ancient Greenlandic culture, history and mythology can be found in Aron's drawings and watercolours. Aron lived in South West Greenland in 1822-69. He was a hunter, but fell ill with tuberculosis and as a result devoted himself to the art of illustration for the last ten years or so of his life. The illustrations were collected by Hinrich Rink (1819-1893), who had held a number of important posts in Greenland, and who took a keen interest in Greenlandic history. Rink urged the locals to write down legends and tales, collected them in plentiful quantities and published several books on Greenlandic mythology and history. In one of Aron's illustration series we see the shaman Unaasaq singing spell-songs against the Danish missionary Hans Egede's ships. As a result Egede's crew suffer from nosebleeds when they go ashore at Salliat, and their desire to conquer the new country suddenly gives way to an overwhelming sleepiness. They all fall asleep and when they wake up again they say goodbye politely and leave the coasts of Salliat as they have come. Much of Aron's production is about cultural encounters between Greenlanders and Europeans, and one could add that the illustrations are in themselves a cultural encounter: the Greenland story-telling tradition is translated by Aron into a western visual idiom.

ARON FROM KANGEQ
Unaasaq synger tryllesang, da Hans Egedes
folk kommer for at angribe, 1867
Unaasaq sings incantation when Hans
Egede's people have come to attack
Watercolour and drawing, 23 x 31,7 cm
Museum of cultural history,
University of Oslo

MARK DION

Polar Bear (Ursus Maritimus), 1992-2002
22 photographs, each 43 x 49 cm
In Situ / fabienne leclerc,
Paris and Georg Kargl

The Lying Fish-Hole

On the edge. The indigenous peoples of the Arctic have long been portrayed as carefree sledders and fishermen by the fish-hole. British writer and Arctic traveller Sara Wheeler takes a sledge ride through Chukotka to meet the indigemous people of the area in their modern-day reality.

As long ago as 1922, one of the first documentary films ever made conjured up the white man's idea of an Eskimo: the lone figure sitting beside his fish-hole as shards of platelet ice shift in the water. The film was *Nanook of the North*, the director a dogged Irish-American called Robert Flaherty who pitched up among a group of Inuit in Port Harrison (now Inukjuak) on the east coast of Hudson Bay in northern Quebec. Flaherty used Akeley cameras fitted with gyroscopic tripod heads and lubricated with graphite rather than oil, as the latter froze like almost everything else. (I found this out myself over many months camping in the Arctic.) For a year, while living in an abandoned fur-trader's cabin, he filmed his neighbours. Difficulties queued up for attention: insufficient daylight, dry snow in the lenses, film that shattered in the cold – but Flaherty sailed home to New York with 75,000 feet of film. The edited version remains a triumph. Who can forget the footage of the hunter Nanook steadying his *umiak* while, from the impossibly tiny hole at the stern, one wife emerges, then another wife, then a series of children of ever-decreasing size, and, finally, the dog?

At the Capitol Theater in New York the movie grossed $43,000 in its first week. Cinemagoers wallowed in images far from the brittle landscape of Scott Fitzgerald's Charleston-twisting metropolis, and the film's reputation spread to lands where moviegoers had to be told what snow was. In Malay, *nanuk* entered the language as a word for a strong man.

Nanook catered to the eternal fascination with the noble savage who led his life in a natural paradise untainted by the horrors of civilization. All colonizers remould Arctic peoples according to their own image – or try to. Hollywood and the rest of the entertainment industry is one example. Communism is another. In the post-Soviet chaos hundreds of thousands of Russian Arctic people from twenty-six ethnic groups are clutching the threads of what they once were and struggling desperately with the consequences of radical social change – a pattern that repeats itself all round the north.

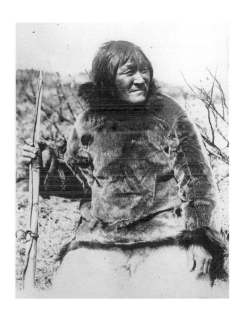

NANOOK OF THE NORTH
Nanook (White Bear)
Port Harrison, QC
Filmstill, c.1920, McCord Museum

ANADYR TODAY

Ninety years after Nanook's story captured the public imagination, a man tucked a baby into a pram outside a block of flats in Anadyr, capital of Chukotka, a desolate Arctic Russian region seventeen times the size of Denmark (you pass though Siberia and keep going). The handlebar had a circular holder for a baby's bottle or, in this case, paternal beer. In an office on the ground floor of the block, posters advertised Bering Sea Biodiversity, and on a bank of desks miniature Chukotka flags fluttered gaily from jam jars when a breeze sneaked in through the ill-fitting windows. I was in the middle of a six-month peri-Arctic journey, and to find out more about the Russian north had requested an interview with Eduard Dzor, President of the Chukotka Marine Mammal Hunters' Association. That morning Dzor was preoccupied with negotiations for an increased whale quota. 'The quota for the whole of Chukotka is five bowhead and 135 grey whales,' he explained as we drank bitter coffee brewed on a portable gas burner. 'Bowheads are difficult to harvest here because they actually swim through Chukchi waters when the surface is frozen, whereas they reach Barrow in Alaska in the spring, so our neighbours there can pick them off from floes. Alaskan Inuit don't hunt greys. But it doesn't mean that those of us west of the Bering Strait might as well switch to grey whales, just because they aren't hunted by our neighbours.' Dzor instinctively recognized the role the bowhead played in native Chukchi communities, economically and psychologically.

ON THE EDGE

Eight time zones from Moscow, but next door to America. Alaskans see *Chukotskiy Avtonomnyy Okrug* from their kitchen windows, as Sarah Palin memorably reminded the electorate in the doomed 2008 Republican campaign. At one point only five kilometres of pack ice and the Date Line separate the two, yet they share no transport links. Chukotka is not only literally on the edge: it is the edge. Indigenous Chukchi are among the most brutally dispossessed of circumpolar peoples. An ethnic group whose presence predates that of the Russians by thousands of years, Chukchi are, or were, reindeer herders and hunters of sea mammals, like most people indigenous to the Arctic.

Food supplies are even more costly in rural areas than they are in Anadyr as everything has to come in by ship in summer, plane in winter. Later that day I paid £8 for five bananas and £5 for three apples. 'There is a lot of talk of Russia's emerging middle class,' said Dzor. 'There are no middle classes in Chukchi villages.' Sharp-eyed readers will have noticed the word *avtonomnyy* in the full name of the Chukotka region. While it is true that Moscow mostly ignores the furthest outpost of its empire, when it comes to its oil and gas, Chukotka and its people have no autonomy at all. The question of how native peoples should or could benefit from mineral extraction is a major issue all round the sub-Arctic, not just in Russia: also in Greenland, in Canada, in Alaska. It not one that will vanish any time soon.

Dzor and I sat back in our chairs thinking about this, returning to the upright to dip our fingers into a bowl of sunflower seeds. Before either of us spoke, the door opened and a third person came through it, momentarily blocking the light. He was a tall, square man with teaky skin, black cropped hair, a generous moustache and efflorescent eyebrows, and his neat, dark suit displayed an enamel Chukotka Deputy badge on the lapel. Petr Omrynto, according to Dzor, was 'the most famous man in Chukotka'. He was certainly among the tallest. A former herder, he had risen through the post-Soviet hierarchy to become the sole indigenous representative in the Chukotka parliamentary assembly. After a blustery start involving too much ribald laughter for me to request a translation, Omrynto began to talk. He liked to talk, especially about reindeer. 'Reindeer', he said as he settled into a chair and stretched his long legs out in front of him, 'are the glue that bind Chukchi culture and society. Even the word Chukchi is the Russian adaptation of the word *chavchu*, meaning reindeer people. During the Soviet period, we had half a million animals. The Soviets saw us as a meat factory.' In the early years state planners had got themselves into a Soviet-size muddle as they tried to apply Marxist ideology to a society which had no industry, no agriculture and no formal leaders. First, how were they to prosecute class war in a classless society? 'Chukotka was already communist,' said Omrynto. 'No class, no leaders, no clans.' How then were junior party cadres to find rich, bourgeois 'exploiters' in order to have someone to punish? Unless they identified class enemies among the natives, they risked becoming class enemies themselves. At last someone hit on a solution. The herder with most animals could be the class enemy! This absurd process was a caricature of the Arctic capacity to reveal and exaggerate system-

ic social and political factors. Soviet determination to convert northern peoples to a sedentary life provided a second hurdle. Herders cannot earn a living sitting still: they must follow the migrations. Through it all, supply lines to Arctic trading centres were so long and so corrupt that little was left by the time goods reached Chukotka except things nobody wanted, such as the fabled 10,000 left-foot gumboots. As for the reindeer, they simply refused to cooperate, migrating every year as if nothing had happened.

POST-SOVIET

Omrynto remembered disintegration on all fronts. He was a mesmerizing speaker, his deep voice filling the scrappy room and his hands, big as root vegetables, conjuring the shapes of the herd flowing across the tundra. He even exuded the rich, smoky smell of reindeer. 'Between the sixties and eighties,' he said, 'when I was herding, every single good social indicator declined, and all the bad ones shot up, suicide and murder rates among them. Whenever it looked like it could never get worse, it did.' De-Sovietization turned out to be as disastrous as Sovietization had been. 'In the nineties people starved. Don't forget that we had no radio and no roads. Imports just stopped.' The indifference of a market economy filled the vacuum left by the collapse of the communist state and Arctic peoples were now victims of the capitalist cult of the individual, a notion that took root in other lands. Of all nationalities, Canadians have tried the hardest to care thoughtfully for their northern tribes. Legislation requires mining operations to pay a dividend to each individual in the community. A good idea, until

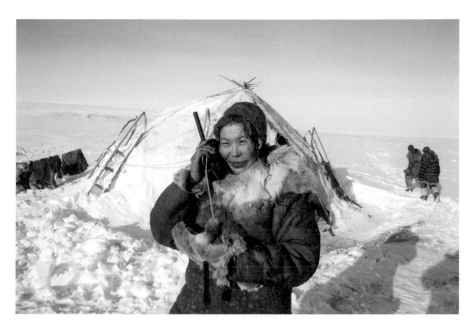

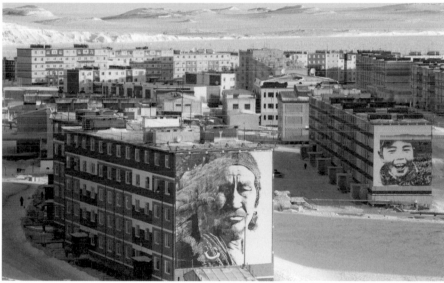

bootleggers appear on the day of the payout and flog alcohol and drugs until every cent is gone. The Arctic is the home of the unintended consequence. As for the Chukchi: many former herders migrated to Anadyr to look for work while Russians left in their thousands when their jobs disappeared along with the old regime. In Anadyr, a resident stuck a card on a telegraph pole advertising his flat in exchange for a one-way air ticket to Moscow.

Over the past decade, reindeer numbers have climbed back to

NATASHA NOMRO
Chukchi woman, using an Iridium Satellite phone at a reindeer herders' winter camp
Chukotskiy Peninsula, Chukotka
Siberia, Russia

CITY LIFE
Brightly coloured apartment blocks in the town of Anadyr,
Chukotka

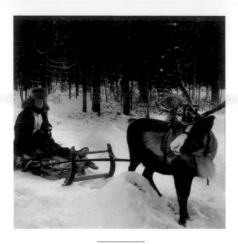

SARA WHEELER
The author and her baby in
the Swedish Arctic

200,000. 'We have even started to
sell meat,' said Omrynto. 'But we
have plenty of other problems.' I
asked him what he considered the
biggest one. 'Alcoholism, without
a doubt,' he shot back, suddenly
grave. 'Eighty per cent of villagers
I represent are drunk on any given
day. To that you need to add other
health issues,' Omrynto continued,
this time wincing. 'Syphilis is still
rife in the villages', and here he told
a long tale about patients nullifying
the effect of expensive antibiotics
with drunken binges. 'I see a lot of
TB. In the worst post-collapse years
of the nineties there was scurvy.'
Cut off from modern food supplies,
Chukchi have forgotten which ber-
ries or whale organs to eat to meet
their vitamin C requirements. They
are stranded in a no-man's-land be-
tween the past and the future. What
with a sky-high suicide rate and
rampant levels of fatal drink-related
accidents, death is always close in
Chukotka. Death, and reindeer.

A HOPELESS ROMANTICIZATION

The depiction of Inuit life the world
swallowed when *Nanook of the North*
became a big-screen smash hit was
a hopeless romanticization as well
as a travesty of the truth. At that
time, life expectancy in Arctic Can-
ada was twenty-eight. Two years
after the film opened to packed
houses, Allakariallak, the man who
played Nanook, died of what was
probably TB. (Flaherty, in thrall to
his vision and with an eye on com-
mercial potential, put it about that
Allakariallak perished of starvation
while hunting caribou.) But nobody
below the treeline was interested
in that. Much later it emerged that
there had been romance all round.
Flaherty had had an affair with
Alice 'Maggie' Nujarluktuk, the
woman who played Nyla, one of Na-
nook's wives, and when he left the
Arctic – never to return – she was
pregnant with their son.

 The polar regions appeal to
something visceral in the spirit,
especially in an era when we have
lost contact with the natural world.
But in the Arctic (unlike the Antarc-
tic), there is a figure at the centre of
the picture, even if he is no longer
fishing at his hole. The chapter now
opening in the north is notably un-
certain for that man. But the Arctic
belongs to him. 'It's not about polar
bears,' says Mary Simon, head of
the Tapiriit Kanatami, which rep-
resents Canada's 45,000 Inuit. 'It's
about people.' ‡

Sara Wheeler (b. 1961), English travel writer, educated
at Oxford University, and member og the British Royal
Society of Literature. Spent seven months at the South
Pole, invited by the US National Science Foundation.
Wheeler travelled the Arctic regions on a reindeer
sledge for two years to gather material for the book
The Magnetic North (2009).

TRIVIA DISCOVERING THE NORTH POLE

Winnie-the-Pooh is the American author Henry David Thoreau's world view translated for children. Thoreau wrote *Walden – Life in the Woods*, in which he concluded that there was no reason to go on voyages around the world when you can reach as far as you want by studying your own back yard. That is Pooh's method – Christopher Robin has an idea: "We are all going on an Expedition", he says – the boy who knows the grown-ups so well that he does not want to be one. "We're going to discover the North Pole". Pooh replies, "Oh – what is the North Pole?" – "It's just a thing you discover," is the answer – quite in keeping, in fact, with the outcome of all the ambitions of the polar explorers. Pooh and company do not need to travel farther than the nearby stream, into which Roo falls and drifts around and is finally fished out by Pooh with a pole he has found. So that's that: "Pooh," Christopher Robin says, "where did you find that pole?" – "I just found it", he says. "I thought it ought to be useful. I just picked it up." – "Pooh," says Christopher Robin solemnly, "the Expedition is over. You have found the North Pole!". "Oh!" says Pooh."

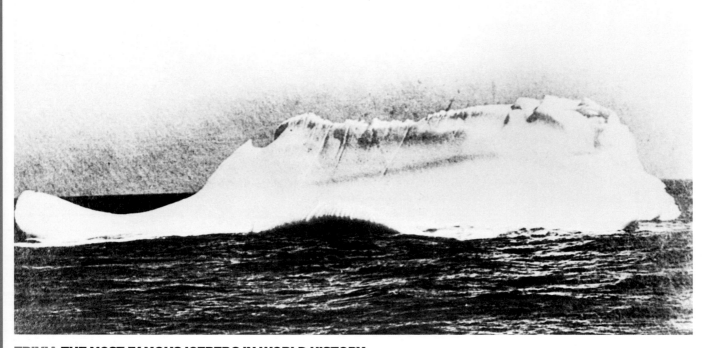

TRIVIA **THE MOST FAMOUS ICEBERG IN WORLD HISTORY**

Every summer icebergs tear themselves loose from the Arctic landscape on the south coast of Greenland and move slowly out of the Arctic Circle, south to the North Atlantic Ocean, where the climate is warmer. Gigantic millennium-old ice masses drift around like ships or floating cathedrals, and create fear and horror among ship captains and cruise guests. Innumerable ships have gone down in encounters with icebergs throughout history, and one such clash stands above them all: on 14 April 1912 RMS Titanic struck an iceberg in the North Atlantic on its way to New York City. The ship that could not sink sank early in the morning of 15 April. From the ships that arrived at the collision scene in the days after the shipwreck there are a number of black-and-white photographs of various icebergs, each of which the photographers supposed was the very iceberg that caused the wreck of the **Titanic**. The photographs are unique, and although they show all sorts of different icebergs, they are formally identical. We see a lump of ice in a sea, and there is no scale to relate to. We cannot see how large they are, but we know from eyewitness accounts that the iceberg was as much as 30 metres in height and 100 metres in diameter, this of course being only the tip of the iceberg. The most famous iceberg in world history has long since melted away but lives on in story.

THE ICEBERG THAT SANK
THE TITANIC
"This is the killer. It is the actual iceberg which caused the British luxury liner Titanic to sink." c. 1912
(unknown photographer)

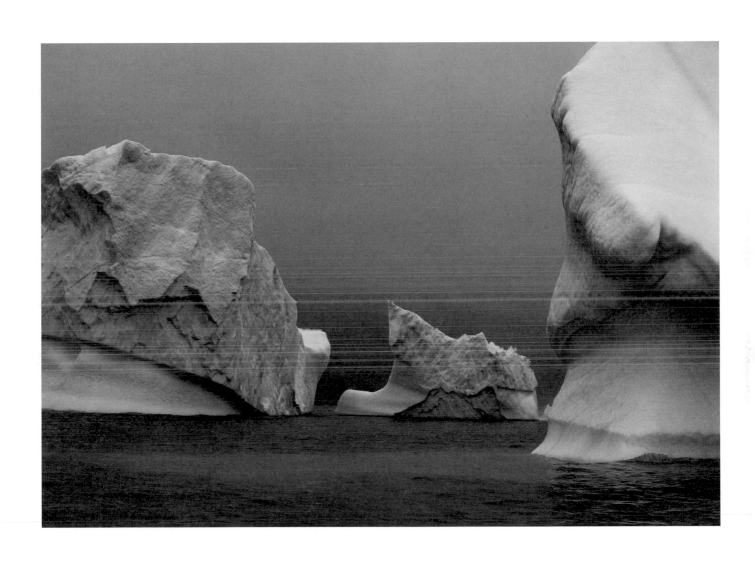

PER BAK JENSEN

Disko Bay, 2007
C-print, 165 x 205 cm
Galleri Bo Bjerggaard

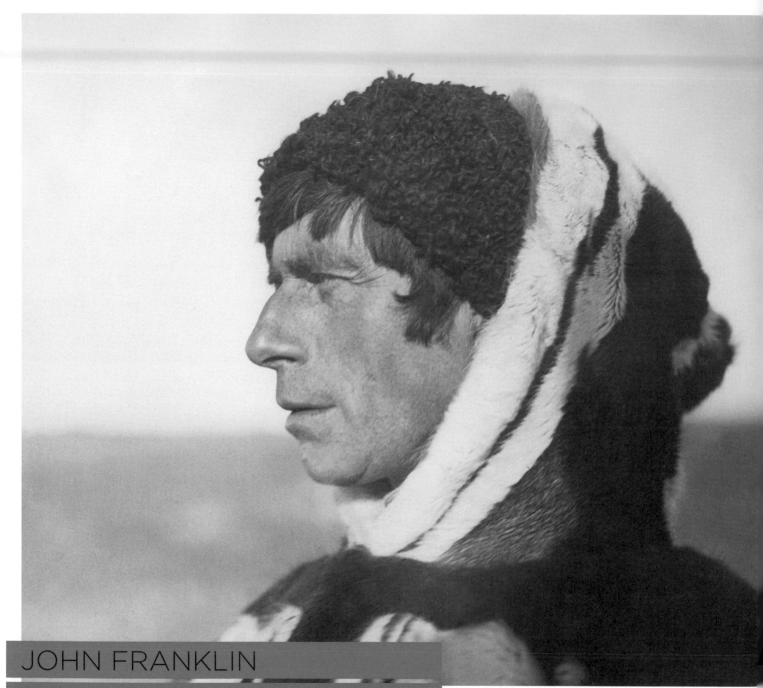

JOHN FRANKLIN

FRIDTJOF NANSEN

COOK & PEARY

S. A. ANDRÉE

KNUD RASMUSSEN 1879-1933

Travellers' tales

ENTERING INTO Knud Rasmussen's world is an elating experience, unlike the one that the other polar travellers in this Arctic exhibition had to offer their time and us. For Robert Peary, Fridtjof Nansen – irrespective of the latter's scientific enthusiasm – and for the almost suicidal Salomon Andrée, the balloon captain, the Arctic seems to have lain there as a great adversary that only had to be beaten to reach the goal. The notes from their journeys are mostly observations that serve the purpose of reaching the North Pole. And the mental climate around the travellers was correspondingly determined by equal proportions of suffering, keeping up their courage and serving the grand cause.

We do not find this mixture of heroism and depression in Knud Rasmussen. True, we know from what he writes here and there that there were harsh times with hunger and exhaustion and hopelessness on tour after tour around the vast Arctic wastes, yet it is still a quite different tone that bears up Knud Rasmussen's commitment to the great North. It speaks of an interest in being where he is, an interest in experiencing the world, people and animals. Perhaps this was because

his desire was not so much to reach something, as to get away from something. His sense of sudden liberation from modernity back in Denmark often makes its impact – and was of course one of the main reasons for travelling around Greenland to document something – the more or less nomadic Inuit culture which, as Knud Rasmussen was well aware, was already under threat at the time.

He was one-quarter Eskimo – or Inut – he was fluent in the language, he enjoyed the trust of the populations he reached, and he had a poetic streak which gave a direction and a voice (although not without hard editorial work) to his awareness of the surroundings, so that the white world could come to life again on the white paper with all the glee of storytelling, the joy of giving, of passing on what he had seen and heard. All this makes Knud Rasmussen a different kind of man from those who came before him: he had a competitive gene, he loved achievement, he was in love with the same great perspective as many of the other heroes, but he was no sportsman. He managed his urges in a quite different way.

While Peary and Cook passed into obscurity amidst the slight puzzlement of the public over what it was all actually about, both between them and for them; while Andrée quite simply disappeared; and while Nansen was glorified with an equal mixture of reverence and awe that approached a cult, people – or at least the Danes – took Knud Rasmussen to their hearts as the great storyteller, as a permanent generosity from the otherwise insatiable and inaccessible Arctic, as a man you liked to spend time with – although only in writing for most people. His books became bestsellers and they did so because they spoke the language of travel using all the best concepts: observation, empathy, narration and the promise of something beyond the text itself, something in which you could invest your longing. You can dream with Knud Rasmussen.

Besides being a formidable dog-sledge driver – that much sportsmanship he certainly had in him – and a great reader of the landscape, Knud Rasmussen was both a scientist and an author, although he was challenged by the establishment in both areas. The Danish author and Nobel laureate Johannes V. Jensen was at first a harsh critic, later he bowed down in admiration and thought that Knud was one of the Nordic primordial men of literature – primitive, which was high praise from Johannes V.! His scientific observations perhaps did not live up to the most rigorous requirements of precision and impartiality, not least because he was so personally intertwined with what and whom he saw and heard. On the other hand it was precisely his intimacy with and love for the people and the country that gave him his advan-

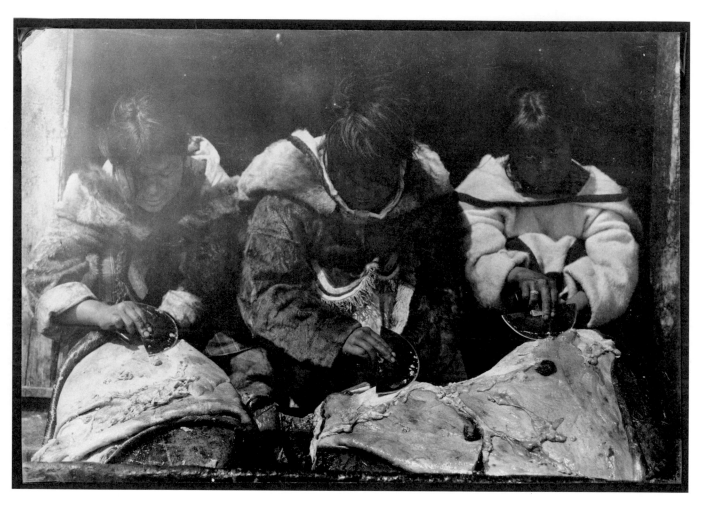

ULO
Fur scraping with ulo at
Great Whale River, Nunavik
Photo taken c. 1910-20

tage. The result was no less than seven so-called Thule Expeditions, named after the trading station that he founded himself with his friend Peter Freuchen and later gave the Danish State – and Knud Rasmussen led six of the seven. The expeditions, which were funded by sales of skins and furs to the fashion market back home, were crucially important to knowledge of the Eskimo and Greenland culture, and from a political point of view they helped to ensure that Greenland remained

part of Denmark in the years that followed. As a scientist Knud Rasmussen was thus original in his own way: besides collecting specimens that can be found today in ample numbers at the National Museum of Denmark, Knud Rasmussen had his gaze fixed on the non-material cultural heritage: the legends and the songs, the dances and the tales – just as he wanted among other things to rediscover the original names of the places in the landscape over which the European expeditions of earlier

times had strewn the names of kings and sponsors. For Knud Rasmussen the local was the universal.

There is an aura about Knud Rasmussen that softens the whole perception of the Arctic, partly by wrenching it out of the sometimes desperate and often frozen grip of the hidebound heroes, partly by showing us the enduring interest behind his commitment: the fact that the Arctic is also a place where people actually live in a symbiosis with nature and have created a symbolic tradition which, not unlike our own, is about how to live where one happens to be. The Fifth Thule expedition, which ranged all the way from Greenland along the north coast of Canada to the Pacific, spoke of all the life that had hidden itself away so well while Sir John Franklin and many others sailed around in confusion, froze stiff and died, and thus helped to elevate the Arctic out of its inhuman demonization and make it a part of our planet. ‡
PET

UKIUVAMIUT
King Island inhabitant with mask
at a spring party in 1924

KNUD RASMUSSEN
Rasmussen demonstrating equipment for
the traditional woolf dance from
Ukiuvak (King Island)
Photographed in Siqnazua (Nome) in 1924

Tiksi

EVGENIA ARBUGAEVA

*T*iksi is a real town, situated on the Arctic coast of Siberia; the girl in the photos is also real. I was born in Tiksi in 1985 and spent my childhood there.

In the days of the Soviet Union, Tiksi was an important military and scientific base. People came from all over the country, some driven by employment opportunities, others driven by a romantic dream of the far North. Although the town is very far north and surrounded by endless expanses of frozen tundra, there was an abundance of beauty.

After the fall of the USSR, the government stopped financing its Northern projects, and many little towns were left to survive on their own. In 1993 my family, along with many others, boarded up the windows of our home and left for a bigger city. I was 8 when we left, and ever since I have never been able to forget Tiksi. The scenery, the fluorescent colours of the northern lights and the moments of pure childhood imagination made a lasting impression on me. I have always wanted to be that little girl again.

In 2010, for the first time in 17 years, I went back to Tiksi. The scenery was still there, but the town was nearly abandoned.

I met Tanya, a young girl who reminded me of myself when I was a kid. She had a similar fascination with the sea and the tundra, and a similar urge to explore her environment. Soon after I met Tanya, she told me how much she admired Jacques-Yves Cousteau – she wore a red hat as a tribute to her hero. She quickly became my friend and my guide to Tiksi.

Soon Tanya's family – just like my own 19 years ago – will leave Tiksi behind. They see no future in the small town and plan to move to a larger city.

I wanted to capture Tiksi, both the way it really is, and the way it exists in a child's imagination. These photographs are like postcards – nostalgic postcards from the imagination of a young girl in Tiksi. ‡

EVGENIA ARBUGAEVA
Tiksi, 2010-12
Photos. Series of 23
Pictura Gallery and the artist

Evgenia Arbugaeva, is a Russian photographer, born in 1985 in Tiksi in Northern Siberia. Graduated from International Center of Photography in New York City. In her work she explores the Arctic regions of her old homeland. Evgenia lives and works in Russia and the US.

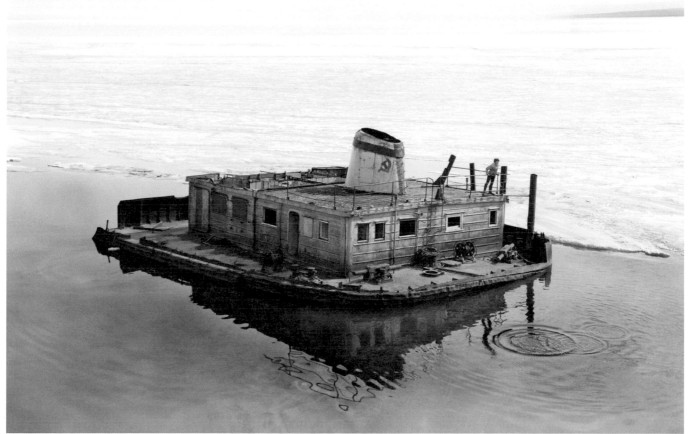

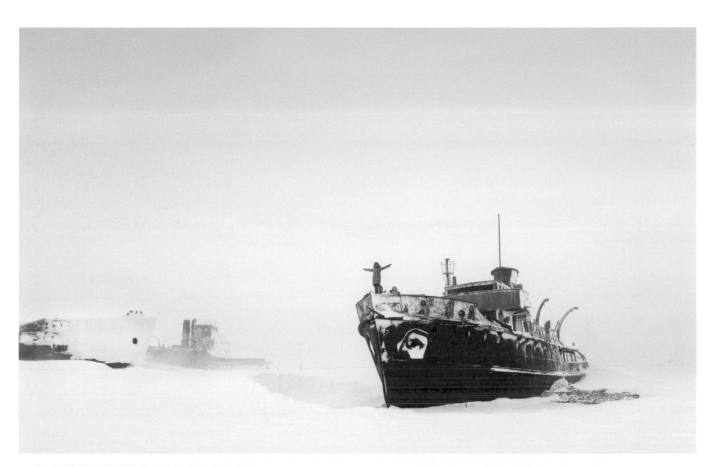
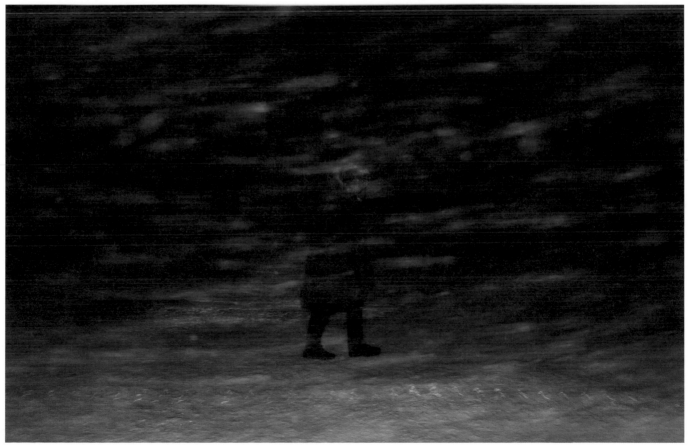

TRIVIA **OLD WOOD**

Cape Kjobenhavn lies in the northernmost part of Greenland, just 600 km from the North Pole. In 1983 researchers found som tree trunks and small pieces of wood there. They assumed that this must have been driftwood from the Siberian forest, for there are no trees in these far northern parts of the world. The Arctic is in fact defined as the land that lies above the tree line. When bones and twigs were subsequently also found in the underground around Cape Kjoben-havn, this first assumption had to be replaced by a theory that the slender tree trunks, twigs and spruce cones that had been found had not been brought to these latitudes by the sea at all. On the contrary, there must have been forest in North Greenland, consisting of coni-fers such as larch, thuja and black spruce. It is now widely supposed that the trunks have their origin in an interglacial period about 2.3 million years ago. Cape Kjobenhavn is an image of the mutability of the Arctic climate, of the presence of the past in the landscape as a result of the almost museum-like preservation conditions, and of the age of human beings as marginal in the greater picture. These tree trunks are a before-and-after image. There will probably be forest in North Greenland again.

TREE TRUNK
Cape Kjobenhavn

112

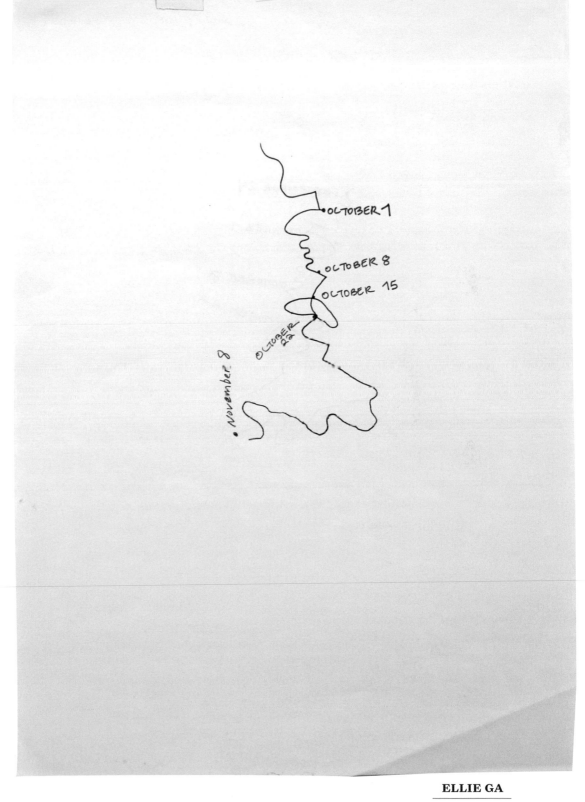

OCTOBER 1

OCTOBER 8

OCTOBER 15

OCTOBER 22

November 8

ELLIE GA

Drift Drawing, 2007-08
Set of nine drawings, marker on paper, tape
42 x 30 cm
Bureau, New York

Glimpses of an Ancient World

An Arctic traveller senses that the past is very close to the present day. It intrudes on the moment, as if we might catch a glimpse of an ancient world out of the corner of an eye. This sense of an immanent past arises from both the physical world and the realms of our imaginations.

To southerners, Arctic landscapes are as alien as those of another planet, yet they also have a haunting familiarity. These are the panoramas of our own ancient past, recognizable from books and films and museum exhibits telling of the great Ice Age. The last Ice Age was a time when mammoths and musk-oxen, caribou and long-horned bison roamed the mid-latitude tundras of temperate Eurasia and America, a time when our ancestors painted portraits of these creatures in European caves, and followed the herds to spread human occupation around the world. I glimpsed this world one clear evening on my first trip to the Arctic. I was camped in the interior of Banks Island in Arctic Canada, a gently rolling landscape that the late evening sunlight had painted in oranges and purples. A movement on the horizon a kilometre to the west of my tent caused me to look up and see a black creature that was slowly gliding along the horizon, down one ridge and up the next. In my binoculars it was a huge mammal with a shaggy coat of dark hair hanging almost to the ground, the sunlight occasionally flashing white from its large hump of a head. This was the first musk-ox that I had ever seen, but after it disappeared over the horizon I realized that what I had been watching in my imagination was a mammoth with flashing ivory tusks instead of horns. The absence of anything by which to measure the scale of the creature's size, combined with my sense of being in an alien place, had easily tricked my mind's eye and taken me deep into a past that no longer existed.

THE PAST PRESERVED

In the real world, mammoths might have survived until relatively recently on Banks Island, long after they became extinct in the mid-latitudes 12,000 or more years ago. On the next island to the west – Wrangel Island off the northeastern coast of Siberia – herds of mammoths lived until about 4000 years ago, protected by their remote location until humans eventually found their refuge. No one knows when the last mammoth was killed in Arctic North America. The Inuit of northern Alaska and northwestern Canada had a name for the animal, and even portrayed it in a string-figure game. However, they describe the creature as living beneath the earth like a gigantic mole, and their knowledge was probably based on the evidence of massive bones and ivory tusks that appear along the shore as coastal erosion eats into the frozen earth. Around the polar world, permafrost has preserved the remains of Arctic elephants and other ancient animals that have lain there for millennia, occasionally eroding to reveal entire creatures with skin and hair intact. Unlikely anecdotes of meals eaten from recently thawed mammoths have long circulated. Some recent finds have produced samples of DNA that are sufficiently preserved to tempt researchers to begin thinking of cloning the animals and bringing an extinct species back to life. Russian enthusiasts have even suggested creating a remote Siberian preserve where recreated Ice Age animals may once again roam the Arctic world.

It is not only the remains of ancient animals that are preserved by the cold of the polar regions. In a few localities on Banks Island scatterings of logs and branches can be found – even the cones and needles of spruce trees, the remains of forests of the kind that now lie several hundred kilometres to the south. This is wood that was freeze-

dried five million years ago at a time when the forests of a slightly warmer world died off with the onset of Ice Age conditions, and which has been so well preserved by the cold and dry climate of the polar desert that it still burns brightly in a camp fire. Signs of an even warmer and more ancient world appear far to the north on Axel Heiberg Island, where a panorama of tree stumps marks the remains of the kind of forest that is found today in the bayous of the southern United States. Biologists speculate that deciduous trees may have developed in this sort of polar environment, the loss of autumn leaves being an adaptation not to cold but to the lack of sunlight during the long polar night in a relatively warm Arctic. It also seems possible that the nocturnal habits of some species may have developed in such forests, as animals learned to live through weeks or months of winter darkness.

MASSIVE SNOWDRIFT
Now unclothed by forest, the rocky bones of Arctic lands lie open to the sky. The ancient geological events that formed the landscape have left

traces that are everywhere apparent. Flights of raised beaches line the coasts like vast series of steps, each as distinct and continuous as contour lines on a map. Each step upwards marks an older beach, formed at sea level as the land gradually rebounded from the weight of glaciers that covered it during the Ice Age. The camps of ancient hunters are scattered across these beaches, marked by small clumps of wildflowers nourished by discarded animal bones. Since most hunters camped adjacent to the shore at the time, each step upward across the raised beaches brings the archaeologist to an older set of camps. So undisturbed are these camps that, beneath a clump of brilliant purple saxifrage, I once found the skeletal paw of an Arctic fox, each tiny bone in place after almost 4000 years.

Little else has changed since the glaciers retreated thousands of year ago, leaving a topography moulded and torn by ice. The remnants of Ice Age glaciers still crown the highlands of Arctic islands and fill the great bowl of the Greenlandic subcontinent. Ice and cold lock Arctic seas and lands into an immobile mass for most of each year, allowing the forces of erosion by wind and wave only a few summer weeks to do their work. Cold slows the rate of chemical processes of transformation and disintegration. Arctic landscapes thus change very slowly. Going ashore on an Arctic island, or climbing to the top of a ridge, one can imagine that one's view is the same as that seen by the first human to have reached this spot centuries or millennia ago. Much of Novaya Zemlya looks as it did in 1596 when Willem Barents and his crew made the first Arctic wintering by Europeans; the remnants of their flimsy house are sufficiently preserved for archaeologists to confirm details of the written account of those horrible months haunted by scurvy and hungry bears. Beechey Island, a small rock and gravel spit in Canada's central Arctic, looks much as it did in 1845 when Sir John Franklin's doomed Northwest Passage expedition chose it as their wintering-quarters. The graves of the crewmen who died that winter are still marked by weathered headboards, and the island is littered with the debris and memorials left a decade later by the crews searching unsuccessfully for Franklin's ships.

Just before wintering on Beechey Island Franklin explored a channel to the north, and here he must have seen tiny Dundas Island. I once spent a few late summer weeks here, investigating the remains of a settlement that had been occupied about 1000 years earlier by a few families of Tuniit, the people who occupied the Arctic coasts of Canada and Greenland before the Inuit. The island was perpetually shrouded in fog, from which emerged the grinding rumble of moving ice and the grunts of walrus feeding between the floes. The site of the village was covered by a massive snowdrift that melted back only during a few weeks in late summer. The area was littered with the bones of walrus and polar bear, indications of successful hunting. The sleeping-areas of the five small tents were covered with mattresses of twigs and moss, and the central hearths contained charcoal and burnt bone fragments that housewives had covered with slabs of stone to preserve them for use when they returned. The ivory tips of harpoons for hunting walrus, and the wooden handles of stone-bladed knives used for cutting up the meat, were perfectly preserved in the gravel where they had been lost, or perhaps mislaid on the evening before the first snowstorm of autumn. It required little imagination to feel that I was picking up someone's personal belongings from a recently abandoned camp, expecting to hear voices speaking in an unknown tongue as the occupants returned through the fog in time for their late summer walrus hunt.

ARCTIC WHALING
In another summer, I encountered the remains of a much different walrus hunt on Svalbard, the group of islands lying in the Barents Sea almost 500 km north of Norway. The seas around Svalbard once supported dense populations of whales and other sea mammals, fed by the myriad smaller lives produced by the confluence of oxygen-rich Arctic waters and the warmth and nutrients carried by the tail-end of the Gulf Stream. More importantly, the animals were protected from humans by the remoteness of these islands. This changed quickly after Svalbard was discovered by Willem Barents in 1596. Dutch and English whalers decimated the whale populations in a remarkably short time, the animals' thick layers of insulating fat rendered to provide food, lamp oil, and grease for the wooden machinery of early European industry. The stone and brick oil-rendering furnaces of 17th-century whalers dot the coasts of the islands, and the Dutch whaling station of Smeerenburg has provided archaeologists with a trove of well preserved early European artefacts, including clothing worn by the corpses in the frozen cemetery.

When the whales were gone,

hunters turned their attention to the walrus, which lived in large colonies around Svalbard's coasts. They soon learned that walrus were dangerous adversaries in the water, but if they could be hunted on land they were easy prey to guns, lances and axes. The recommended technique was to kill the animals closest to the water, piling up a wall of corpses that prevented the others from reaching the sea. The remainder of the colony was then driven inland and hunted down individually. The surfaces of such killing sites are littered with the white bones of the dead, numbering hundreds of animals. At one locality near Kap Lee the bonefield extends across a flat foreshore and continues up a steep hillside, narrowing as the last survivors clung together in their desperate attempts to climb the rocky slope. I was not the only visitor brought to tears by the thought of these creatures, so ungainly on the land and so full of fear that they attempted impossible feats in trying to escape their inevitable destruction.

NO CULTURAL STAGNATION

During the past two decades, Arctic whaling has provided another very unexpected contact with the past. The last of the great northern whale populations, the Bowheads of Arctic North America, were practically exterminated by the time that kerosene and other petroleum products replaced whale oil during the early twentieth century. Limited whaling began once more during the 1980s, when Alaskan and Canadian Inuit obtained licences to kill one or two whales per year for food and in order to restore the cultural traditions that had been so important to their communities in the time before commercial whaling. The Inuit who butchered these whales soon began to report finding old harpoons buried in the animals' blubber. The first to be found were weapons tipped with stone blades of the type that had been used by Inuit and Siberian hunters before 19th-century commercial whalers introduced harpoons of iron and brass. Bowheads were thought to live for only a few decades, and it had been a century or more since stone harpoon blades had been used in Alaska. For a few years there was speculation that somewhere, perhaps on the coasts of Siberia, there were people who had clung to the old ways well into the 20th century. The true explanation became apparent when whales were found to be carrying harpoon tips from the commercial whaling period, including one brass dart that could be securely dated to the 1880s. The whale that had been struck with this weapon had apparently carried it for about 130 years. Bowhead whales are now thought to be the world's longest-living animals, thanks to a metabolism slowed by life in frigid seas. Whales that were young when Franklin's doomed crews wintered at Beechey Island may still be cruising the ice-rimmed channels of the Arctic.

The imminence of the distant past enhances our fascination with the Arctic regions. However, this is a quality that we mistakenly apply to the indigenous people of the far north. For many, the Inuit of Arctic North America are the archetype of the 'aboriginal'. They are thought of as a people whose ancestors have lived for untold generations in isolation from outside influences, and who have perpetuated an ancient way of life into the modern world. This view was perhaps best expressed by the explorer and anthropologist Vilhjalmur Stefansson, who wrote widely on his experiences among the Inuit during the early 20th century. Recalling his 1910 encounter with a group of people in the central Canadian Arctic, he wrote "Their existence on the same continent as our populous cities was an anachronism of ten thousand years in intelligence and material development. They gathered their food with the weapons of the men of the Stone Age, they thought their simple, primitive thoughts and lived their insecure and tense lives – lives that were to me the mirrors of the lives of our far ancestors whose bones and crude handiwork we now and then discover in river gravels or in prehistoric caves".

A similar perspective has been adopted by the Inuit art industry, a commercial enterprise that is economically important to several Canadian Arctic communities. To promoters of Inuit art, the unique spirit that marks works created by Inuit artists arises from the collision of their ancient way of life with the challenges of the contemporary world. Such a view may be useful in selling art, but has serious consequences for the way in which Inuit are treated in other fields of endeavour, such as education, employment, and political development. Indigenous people are too often thought of as possessing qualities not found in peoples of mainstream world societies – spiritual awareness, an unbreakable bond with the land, and the capacity to preserve and use ancient wisdom – together with an unwillingness or incapacity to adapt to contemporary circumstances. They are admirable, but not quite ready to join the modern world. Such views are, of course, absurd.

Archaeology shows that the Inuit are not the descendants of an ancient and isolated culture that adapted over the millennia to the environmental conditions of Arctic Canada. In fact, their ancestors immigrated to Canada and Greenland from the much richer environments of northwestern Alaska only a few centuries ago. These were people who, for the previous millennium, had controlled the Asiatic iron trade across Bering Strait, and their eastward migration appears to have begun as a commercial endeavour: the opportunity to acquire metal tools through trade with the Norsemen who had established settlements in Greenland. Inuit history shows no long period of isolation or cultural stagnation, but a continued engagement with the commercial interests of the outside world. Inuit are as capable as any of living and working in the modern world. In doing so, they are held back only by the preconception that the Inuit, Saami, and other northern peoples are living representatives of an ancient world. It is we southerners who sense the imminent past in Arctic landscapes. To the people of the country, the Arctic is a beloved homeland and a normal part of the wide world. ‡

Robert McGhee (b. 1941), Canadian archaeologist and author specializing in Arctic archaeology. Fellow of the Royal Society of Canada and author of the book *The Last Imaginary Place* (2005).

PEDER BALKE
Nordlys over klippekyst, c. 1870
Northern Lights above Rock-Bound Coast
Oil on paper mounted on plate, 10,5 x 12 cm
Nasjonalmuseet for Kunst,
Arkitektur og Design, Oslo

JOACHIM KOESTER

Message from Andrée, 2005
16 mm film, posters and text
Galleri Nicolai Wallner

1 . 9 . 1 . 9

Thule-Gesellschaft

TRIVIA THULE SOCIETY

Ever since the Greek geographer Pytheas (380-310 BC) there have been reports about the mysterious Thule in the north. Pytheas' own journey has been the subject of much discussion. Nansen, for example, thought that he visited Norway – and the many interpretations have all added to the same myth: Thule has been turned into a legendary place, a projection surface for ideas and fantasies about all sorts of things. Some of the worst ideas throve around the time of the First World War in Munich, where the right-radical fantast and self-appointed nobleman Rudolf von Sebottendorff headed *Die Thule-Gesellschaft*, the Thule Society, which counted Hitler and Hess among its early members. The main object of the Society was to maintain the idea of Thule as the place of origin of the Aryan race, in increasingly rabid attacks on Jews and Communists – attacks that finally culminated in the Nazi Party's seizure of power in Germany. Despite the efficient anti-Semitism, Sebottendorff's mumbo-jumbo became too much even for Hitler, and he was sent out into the cold – he drowned in the Bosphorus. If you search the Net for the Thule Society, you don't have to trawl through many pages before you come across Satanism and anti-Semitism, marketed to this day under the same heading.

THULE-GESELLSCHAFT, 1919
The Thule Society Emblem

An Idea
of
Absolute
North

The tragic tale of Sir John Franklin's last expedition haunts all British imaginations of the Arctic. Peter Davidson investigates this peculiar relationship with the concept of heroism in the absolute North.

We all carry our own idea of the North within us,' as I wrote a few years ago in my book *The Idea of North*, but do we also carry within us an idea of the Absolute North, of the high Arctic? Like all our ideas of norths, I think that our idea of the farthest north, of the Arctic, is at once personal and culturally determined. I would like to explore this idea in this essay: beginning with personal experience, then moving to consider the absolute North from the perspective of the community in which I live, Aberdeen and Northern Scotland. Finally, I would like to consider those myths and imaginations of the Arctic which still haunt the English-speaking world.

I.

I have twice visited the Arctic, but I have never been further north than 70 degrees: once I made a beautiful summer journey on Finnmark buses and Norwegian coastal steamers. But even in northernmost Norway, there were aspects of the things about me which felt as if they belonged to a different order of nature from the northern Scottish order with which I am familiar. It was as though this region, simply by its translucency, its shadowless clarity and its qualities of light, partook of the nature of an otherworld, like the supernatural kingdom which constantly re-appears in old Scottish ballads.

I remember especially standing fascinated beside an oxide-red farmhouse on the shores of the Tromsø fjord. In late May, when the treeless shores were brilliant in summer light, the still landscape around it was a place for which I could barely find words. There is a little stone jetty in the still water: water like pewter, extraordinary water, water unlike the water of the world I know.

My experience of Arctic Finland also had an element of the otherwordly: I remember especially a moment which was an enigma of the light, the same extraordinary light of the high latitudes which had so moved me in Norway. Oulu was welcoming in high summer, with wooden houses on islands, the Baltic lapping at beaches of dark pebbles, the smell of flowering rowans and Stockholm tar. There was sunlit water at the end of every lane. I walked with a friend along a woodland path, as he told me about the sea frozen at midwinter and how at that dark season it was possible to walk out to the blue islands far out into the bay. Further north, he said, you could hike or drive on it, all the way to Sweden. We came suddenly on to basalt rocks bordering the sea, with the dazzling track of the midsummer sun coming straight through the sandbar which sheltered the bay. A young man was swimming there, quietly and alone, swimming breaststroke with barely a ripple – until he moved out of the shadowed waters and his tow-fair head vanished in an instant into the brilliance of the high sun on the sea. It seemed a small manifestation of the famous deceptions and refractions of the high Arctic air – false suns, illusory islands.

It is part of the inheritance of Europe to be haunted by imaginations of the absolute north – as W.H. Auden said of Iceland, when he revisited the country in old age, all his life he had not consciously been thinking of the island which he had visited as a young man, but there was never a time when he could assert that he was *not* thinking of it. And it is not only part of the inheritance of northern Europe, of those countries which have had prolonged contact with the absolute north: one

GRAVES OF SIR JORN FRANKLIN'S MEN, dated 1846
Beechey Island, Nunavut, Canada

of the most enigmatic Arctic objects which I have even seen came from southern Spain, from my mother's family. It was a lithographed backdrop for a child's paper theatre, showing an encampment deep in the Arctic snows (complete with ice-floes and polar bears in the distance, the aurora overhead in a curiously red-tinged sky) but with the crimson and yellow flag of Spain flying triumphally over the tents and stockade. It is barely possible to conjecture the play of which this scene formed a part.

The absolute north is always there, lying in wait for us and for our emotions: I remember one Autumn twilight in Copenhagen, wandering around, simply enjoy-ing the streets, and coming upon Det Grønlandske Hus and being overcome by a momentary excite-ment, which was also a nostalgia for a place never visited. It was at once a longing for travel and a vivid re-membrance of the old far-northern connections of the city: the Kings of Denmark ruled the distant regions of Finnmark and Greenland — and those kings had a throne made of narwhal ivory.

Quite often I visit friends in an old house in the country just to the north of Aberdeen: in a dark up-stairs corridor is an extraordinary object, one of the more horrible productions of Victorian ingenuity: a dinner gong suspended between two long, finely-matched narwhal tusks. I think that the family have long been involved with the compa-ny which manages the Harbour of Aberdeen (which is, extraordinarily, the oldest company in Europe) and perhaps the spiral tusks came to them through that connection. But even in that debased context, these objects have powers of imaginative association, the ability to lift the mind to the north at the summit of all the norths.

As do all public houses and cafes called the North Star or the Seven Stars. I have a private geography of these: an unremarkable brick pub called *The North Star* which sheds a cool lustre on an arterial road in West London. A shabby street to the north of Euston Station, noisy with traffic and trains, one of those Lon-don streets where it always seems to be raining, but illuminated by a pub called *The Seven Stars,* with its reminiscence of 'the region under the Seven Stars'. An equally shabby granite street in Aberdeen, downhill from the main street towards the harbour and the railway station, is glorified by a bar called *The Old*

Starry. Most enigmatic of all, in a city not short of enigmas, just a block inland of the Orthodox Cathedral in Trieste is a corner cafe called the *Caffè Stella Polare*. Tradition identifies it as the cafe of the Serbian merchants, who had their houses and their church on the quays along the neighbouring canal in the days of the Habsburgs, but there is no explanation for the name, whose poetry only intensifies in the heats of high summer, when the far north seems unreachably remote, a place of the imagination.

Thoughts of the high north, far to the north of that 'north' which I inhabit, remain always at the edges of the imagination: fragile, imaginary talismans held in cupped hands – a tern's egg, fluorspar like clouded water, sherds of crockery and rusted tins which are the dark memorials of those explorers lost on the search for the North-West Passage.

II.

Aberdeen is the northernmost city in Britain. Its whaling ships of the nineteenth century often found their ways to the high north, to the ice off Spitzbergen and Greenland. The city was on the route of the often luckless British Arctic expeditions of the nineteenth century, which would sail up the east coast from the Thames, and put in at Aberdeen before sailing onwards to a last call at one of the Orkney ports, Stromness or Kirkwall, to take on water, provisions, last-minute recruits. (One of the many men who died on the disastrous Franklin expedition of the 1840s, bore the unmistakably Orcadian first name of Magnus, after Earl Magnus, the patron saint of the Orkneys.)

I work at the city's ancient university, where part of what I do is to assist those who are the curators of its ancient library and museum collections. Thus I have a sense of how those collections reflect a growing knowledge of the absolute north, almost a northern Scottish history of the idea of the absolute north. This is a fascinating microcosm, an image of growing European knowledge of, and interest in, the Arctic lands.

The library also holds a well used edition of the mid seventeenth century account of the collections of the Danish natural scientist Ole Worm: *Musei Wormiani Historia*, published at Leiden in 1655. This catalogue is celebrated for its frontispiece engraving of the museum-room itself, in all its crowded, baroque, poetic strangeness. Indeed the powerful appeal of this image has led the contemporary artist Rosamund Purcell to recreate the *Wunderkammer*, first at Santa Monica and Harvard and then, permanently and with authentic material, at the Geological Museum in Copenhagen. What is striking, the more you study this image, is just how much of the material in this *Wunderkammer* is of high northern origin, that it is in part a museum of the most distant territories of the Danish monarchs.

My university has displayed museum collections since the early eighteenth century: our first recorded exhibit – an Inuit kayak which is still on show – duplicates one in the Musaeum Wormianum. This boat came to Aberdeen in the earliest eighteenth century as its owner was apparently blown far off course by high winds and ended up taking refuge in the river port of Aberdeen. This long connection between the Northern Isles and Arctic America eventually produced Dr John Rae of the Hudson's Bay Company, one of the few nineteenth-century arctic travellers to retain today a genuine standing as a heroic, even exemplary, figure. It is significant that his own era accorded him no such status.

III.

Quaesivit arcana poli vidit dei: he sought the secret of the poles, he saw the secrets of God is the (highly questionable) inscription on the Scott Polar Research Institute in Cambridge, which I used to pass daily when I was a student. (The Institute itself has evolved into a wholly benign and progressive focus for scholarship and research.) Polar disasters are part of the body of legend which will not leave British culture alone. The heroic failure of the Scott expedition to the Antarctic; the deadly Franklin expedition to the American Arctic. It is a haunting rather than a heritage.

In the 1930s, W.H. Auden and Christopher Isherwood used the phrase 'the north-west passage' to express the futility of all straight masculine heroics – all self-wounding, self-testing feats of futile endurance. They preferred their own queer path of simply proceeding across the 'broad America' of life, without indulging in suicidal bravery in the ice-fields off northern Canada.

The British failures at the pole ultimately stem from extremely bad science, arrogantly applied. Fallacious ideas of nutrition and self-control (the élite Victorian idea that 'abstinence is always best') combined with the widely-believed legend of the 'open polar sea' were dangerous enough. But the literally deathly English idea was that of the Arctic regions as *Terra Nullius* – an empty silence waiting to be named and mapped and *shaped* by the naval expeditions. The wisdom of

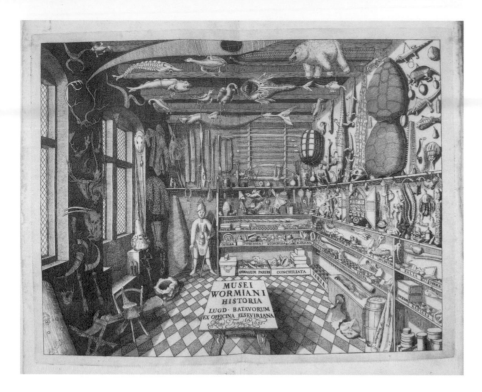

the pragmatic approach of those, like John Rae, who had actually lived and worked in the Arctic now seems unanswerable: this is *inhabited* land, with a history and a topography, and accommodation to it can only be learned by communication with the people who live there. Rae took a small expedition into the high Arctic to trace the remains of the great naval expedition led by Sir John Franklin: they travelled light, in constant communication with the Inuit people. They all returned alive to recount that the Franklin expedition had ended in failure, extinction, cannibalism. Rae was promptly marginalized – as an Orcadian, not a proper Englishman, his standing further compromised by his

friendly relations with indigenous peoples.

The disjunction to some extent survives, in that the Franklin expedition is an idea which is still present. It is serious unfinished business, kept alive by the exhumations and autopsies of the bodies buried on Beechy Island, and the discoveriy that the expedition was being poisoned by its own tinned provisions, another instance of fatally bad science. Yet for the Canadians, the Beechy Island grave site, still remote at 74 degrees north, may be a source of pride but it is also a national *memento mori*, a place to remember in humility human limitations and the powers of the absolute north.

I am not sure if English culture still finds the inutile deaths of brave young men romantic— it certainly is not a sentiment felt by those of us who are British but not English. But whenever the idea of north is discussed, eventually absolute north, Arctic north will come into the conversation, and the haunting and

terrible *Ballad of Lord Franklin* will be quoted by one of the surprising number of people who still know it by heart.

Yet it is not there that I would wish to end, but with my own quiet attempt at an exorcism: with the composer Paul Mealor and the acoustic composer Pete Stollery I wrote *74 Degrees North*, a chamber opera commissioned and performed by Scottish Opera. It is in the form of a *Noh* play – a visit to a famous grave and an exorcism, like Britten's *Curlew River*. The grave is that of the first man to die on the Franklin expedition; the pilgrim is a scientist, an admirer of John Rae. After long colloquy, he attempts (to circling, fading, remarkable music) to sing the ghost and the past to rest:

I grieve for you, for all of those the north
Holds in its cloudy prison of the snows.

Ships like great gulls left Kirkwall for the ice
By freezing sea-roads they could not retrace

Those few came far to lay their bodies here
To hold a place in the green world no more

Ice thickens, daylight fails in winter cold
Dark save the starry guardians at the pole. ‡

Peter Davidson is Professor of Renaissance Studies at the University of Aberdeen in Scotland. He is the author of the book *The Idea of North* (Reaction, 2005), about western culture's understanding of many different Norths, including the Arctic.

DE RIJKE / DE ROOIJ

I'm Coming Home in Forty Days, 1997
16mm-colorfilm, 15 min
Galerie Buchholz, Berlin/Cologne